IMAGES
of America

RHINEBECK

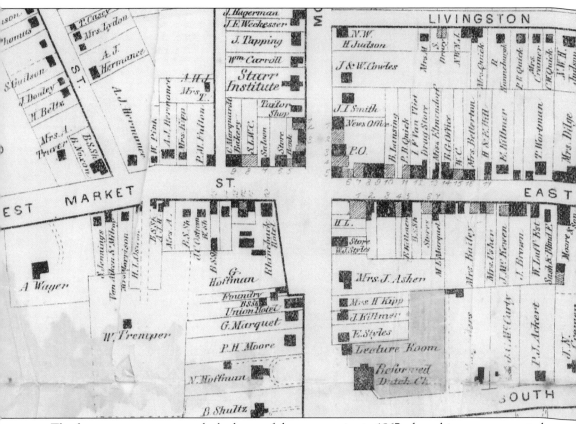

The four corners were as much the heart of the community in 1867 when this map was created as they are today. One difference is that the road was wider in front of the Rhinebeck Hotel (today's Beekman Arms) at that time. The extra space was the site of the town water pump. It was both a place for horses to quench their thirst and for acquaintances to stop and talk. (Rhinebeck Historical Society.)

IMAGES
of America

RHINEBECK

Michael Frazier

ARCADIA
PUBLISHING

Published by Arcadia Publishing
Charleston, South Carolina

Printed in the United States of America

Library of Congress Control Number: 2011944785

For all general information, please contact Arcadia Publishing:
Telephone 843-853-2070
Fax 843-853-0044
E-mail sales@arcadiapublishing.com
For customer service and orders:
Toll-Free 1-888-313-2665

Visit us on the Internet at www.arcadiapublishing.com

To Cecily, whose support has been invaluable, and to my grandchildren Jack, Sophia, and Olivia, who I hope will enjoy and learn as much from history as I have.

CONTENTS

ACKNOWLEDGMENTS

There are many people I want to thank for helping in the preparation of this book.

The Museum of Rhinebeck History and the Rhinebeck Historical Society deserve the greatest credit for collecting, accessioning, and describing photographs in their collections. Special thanks to Steven Mann, Beverly Kane, Kay Verrilli, Ada Harrison, Rebeccah Johnson, Nicholas McCausland, and Elaine Cruickshank. The Quitman Resource Center for Preservation and the Starr Library have been generous in sharing their resources and permitting me to use their space to do much of my work. Thanks to Wilderstein Preservation and the Chancellor Livingston Chapter of the Daughters of the American Revolution for ransacking their archives for relevant material. Local residents with extensive knowledge of Rhinebeck's history were especially helpful, most notably Alan Coon, Nancy Kelly, Kay Verrilli, Marilyn Hatch, Elma Williamson, Bill Gay, Tom Schaad, Catherine Hall, Patsy Vogel, and Ruth and David Queen. Sources from outside Rhinebeck who went above and beyond in their search for material and accuracy of facts include Ken Gray of the Ulster County Archives, the staff of the Manuscripts and Archives Division of the New York Public Library, Jerry Mastropaolo of the Hudson River Maritime Museum, Robert Wills of the Hudson River Ice Boat Club, and Helene Tieger of Bard College.

Local photographers without whom this work could not have been considered include John Coumbe, Harry Coutant, F. DuFlan, Ed F. Tibbals, V. W. Schaffer, Theo deLaporte, Frank Asher, and Tom Daley. Local historians, all giants on whose shoulders I stand, include Edward Smith, Howard Morse, Helen deLaporte, Arthur Kelly, Nancy Kelly, Sari Tietjen, Cynthia Owen Philip, Marilyn Hatch, Christopher Lindner, and especially the many reporters and editors of the *Rhinebeck Gazette* who for 163 years, until 2009, never paused in recording local history.

I hope that anyone whom I may have unwittingly forgotten to thank here will forgive my oversight.

The images in this volume appear courtesy of the Rhinebeck Historical Society (RHS) and the Museum of Rhinebeck History (MRH).

INTRODUCTION

This book is about the people who made Rhinebeck what it is today and how they lived. The nine chapters focus on aspects of those lives.

An archaeological dig in 2006 uncovered a diversity of tools scattered widely and thickly enough to suggest that a site at the western edge of the village of Rhinebeck served as a base camp about 5,000 years ago. Continuous settlement is much more recent, dating from 1700 A.D. Religion has always played a prominent role, and many older churches continue to this day as important community centers. The town's rich soil, rolling landscape, access to water, and mild climate are well suited for farming, but only for farmers willing to devote countless hours clearing rock and enduring the vagaries of weather. The violet industry brought in considerable revenue for many years. For merchants, the community's location at several important crossroads continues to serve as a blessing. The more fortunate merchants have reciprocated over the years by using their wealth to pull the community through difficult times.

Since the Revolutionary War, Rhinebeck's response to the nation's call for troops has always been above and beyond the national average, as has the home front's support for those who have served. The town's ability to thrive has also depended on a solid infrastructure of public servants. Teachers, firefighters, town officials, and health workers are but a few examples of the occupations that needed to be filled. A few of the rich and famous have built grand estates in Rhinebeck.

Parades and public celebrations have been an important part of life, whether Memorial Day parades or Liberty Bond drives. Dutch Christmas has returned in the form of Sinterklaas, to the great delight of thousands. Rhinebeck had the Rhinebeck Aerodome, an early outdoor movie theater succeeded by a movie theater at the Starr Building. And the Rhinebeck Center for the Performing Arts, after starting out in a tent, now has its own home where performances can be enjoyed throughout the year.

Rhinebeck's earliest land transaction occurred June 8, 1686, between three Native Americans and three Dutch residents of Kingston. Such agreements could not become legal unless acknowledged by the king of England; King James II issued a patent on June 2, 1688. The king required of the new owners "forever, yearly, and every year, the quantity of eight bushels of good, sweet, merchatable winter wheat." The Native Americans had received "six cloths of strodwater, six cloths of duffel, four blankets, five kettles, four guns, five horns, five axes, 10 cans of powder, 10 strands of lead, eight shirts, eight pairs of stockings, 40 fathom of wampum or sewant, two drawing knives, two adzes, 10 knives, half an anker rum, one frying pan." (Archives of the Ulster County clerk's office, Kingston, New York, Nina Postupack, Ulster County clerk.)

One

EARLIEST RESIDENTS

A 2006 archaeological study found evidence of human activity in Rhinebeck about 5,000 years ago at a site not far from the Starr Library that may have served as a base camp for various bands' social gatherings. More recent, but still very early, evidence of human activity in the area was confirmed by a petroglyph along the eastern shore of the Hudson River, estimated to have been created around 1100 A.D.

In Rhinebeck's earliest recorded land transaction, Native Americans in the late 1600s agreed to be displaced eastward to the portion of Rhinebeck still known as Mansakenning, while Dutchmen settled the riverfront area later called Kipsbergen. Hendrick and Annatje Kip established the first homestead in 1700, followed by relatives Jacob and Andrew Kip. The Kips showed great foresight when they set up a ferry, the earliest business enterprise in Rhinebeck. Ordinary life for the earliest residents was never easy. The river's comings and goings governed their livelihood, while the residents of the inland town were more dependent on farming and on goods and travellers who arrived on the King's Highway or the Sepasco Turnpike. All residents faced the same challenge—surviving difficult winters and long stretches of isolation. The Palatines, who responded to Henry Beekman's invitation to settle inland Rhinebeck at Wey's Crossing in the northern part of the town and at the Flatts closer to the center, brought with them a knowledge of farming that proved an advantage in taming what was then a wilderness.

Though most of the earliest residents were never photographed, in very early images of the Travers and the Kilmers, they look as if they are trying to explain what life was like for them. Earliest residents also included successful entrepreneurs. William Kelly and William Wood, for example, used their wealth for public projects in service of the community.

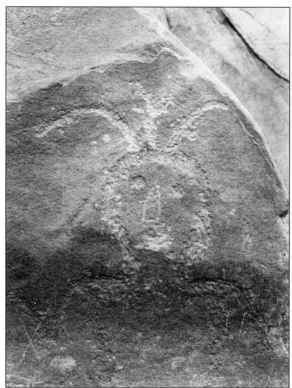

Allan Frost gave this 1930 photograph of a riverfront petroglyph to property owner Robert Suckley, whose father, Thomas Suckley, had bought the property in 1852 and had named it Wilderstein after this rock. The Dutchess County Historical Society describes the image in their 1931 yearbook as a c. 1100 A.D. Indian sachem. Rock art expert Edward Lenik sees striking resemblances to an Esopus petroglyph. (Wilderstein Preservation.)

This cemetery in Rhinecliff is known as Kerk Hof, which is Dutch for "Church Yard" or "Cemetery." Donated by the Van Wagenen family in 1750, the land has a good view of the other side of the river, where most of Rhinecliff's earliest residents originated. Kerk Hof is one of the oldest cemeteries in the county; its earliest burial dates to 1749. (RHS.)

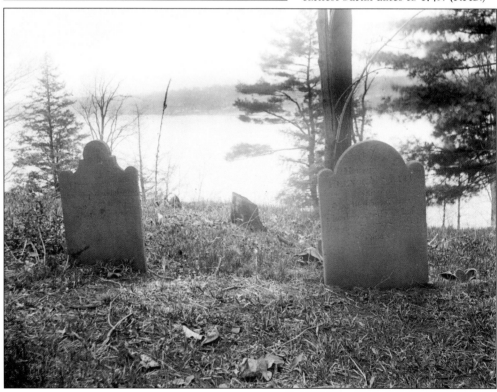

Seen here in 1915, the Jacob Kip house, built around 1708, still hugs the shore at the bottom of Long Dock Road in Rhinecliff. This house and the Abraham Kip house (its uphill twin) were perfect locations from which to manage the family's franchise of the ferry to Kingston. Below at left, Anna Nehr (1799–1870), of one of the original Palatine families, was baptized at Rhinebeck's Stone Church. She married the aristocratic Charles Crooke (1794–1875) in 1819. Charles (below, right) inherited land near Rock City from his father, John Crooke, listed as one of Rhinebeck's slave owners in the slave census of 1755. Both Anna and Charles are buried in the Poughkeepsie Rural Cemetery. These two c. 1867 portraits are the earliest photographs in the museum's collection. (Above, photograph by Harry Coutant; all, MRH.)

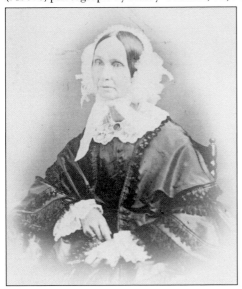

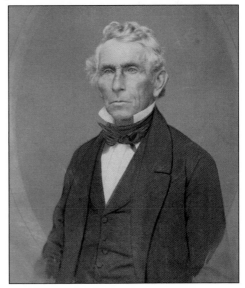

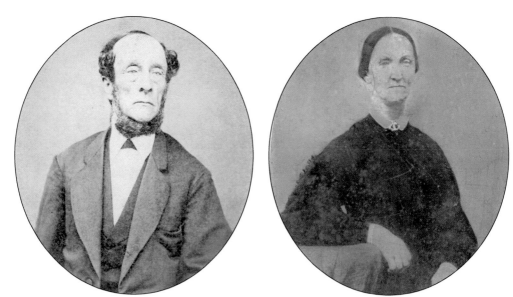

Born in 1813, Morgan Traver was a farmer, merchant, and schoolteacher. He married Phoebe Schultz, who was born in 1812. The family supported the Lutheran Church and was especially proud they could send their daughter Isie to school at Rhinebeck's DeGarmo Institute. Isie later married her cousin and prominent agriculturist William E. Traver. The house below is at the opposite end on the spectrum of local housing from the grand estates associated with Rhinebeck. A note on the back of this c. 1890 photograph identifies it as being "possibly Oak Street." Regardless of the house's modest appearance, the broom this woman is wielding indicates she wants it to appear at its best. (Photograph above left by John Coumbe, MRH; below, Minerva Bravender, MRH.)

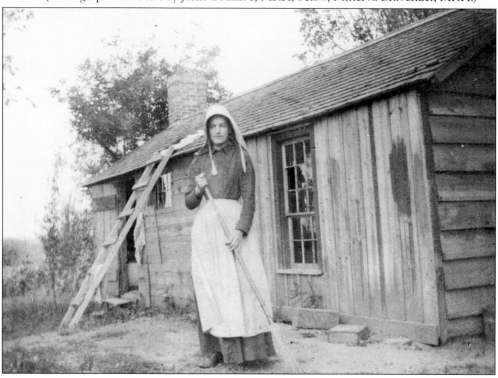

Pictured here around 1919, this house, built c. 1774, was near the Landsman's Kill below its junction with the Rhinebeck Kill. In the late 18th century, it was the residence of Richard Montgomery's miller. The note, which may have been written at the time of the photograph, states, "A stone millwheel may still be seen in the creek near this site." (Photograph by Harry Coutant; MRH.)

Until 1822, William Wood owned property in Rhinebeck and Long Dock, inherited from his father, Capt. Ebenezer Wood, who had lived in a redbrick mansion he built there. William traded the property for 2,500 acres in Athens County, Ohio, 650 acres of which became part of Ohio University. He moved to Ohio soon thereafter. He was also a founder of Wesleyan Female College. (Lithograph by Western Biogl. Publ. Co.; MRH.)

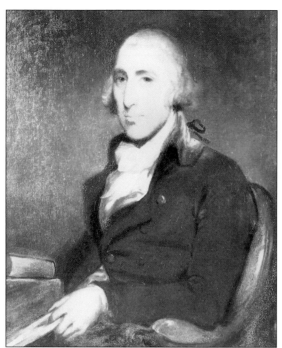

Thomas Tillotson (1751–1832) was appointed surgeon general of the Army in 1780 and served in that role through the end of the Revolutionary War. From 1790, he represented Dutchess County in the assembly and senate, and from 1801 to 1807, he served as New York's secretary of state. He married Margaret Beekman Livingston and built Linwood. The property today is a Catholic retreat house. (Portrait by Gilbert Stuart; RHS.)

Janet Livingston and her husband, Richard Montgomery, lived here in 1773 while waiting for Grasmere to be built. He was killed in 1775 leading the attack on Quebec. She moved alone into Grasmere, then later to Montgomery Place. In 1930, Helen deLaporte donated the house to the Chancellor Livingston Chapter of the Daughters of the American Revolution as a chapter house and museum. (Photograph by Frank Asher; MRH.)

Henry Beekman Livingston (1750–1831), who accompanied General Montgomery to Canada, was awarded a sword for his service in the capture of Chambly in 1775, and he became aide-de-camp to General Schuyler in 1776. This 1828 letter declines a relative's offer for financial help. Proud of the work he had just done on the Kip–Beekman–Heermance house in Rhinecliff, he states that "my advanced age will not justify an idea of being much longer upon it." (MRH.)

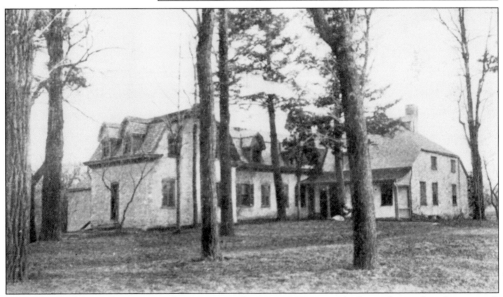

The Kip–Beekman–Heermance house is seen here in 1908, a year before it burned to the ground. Many of the stonewalls remained, but over the years they too began to fall, suffering a coup de grace when stones were taken from the site to build the new Rhinebeck Post Office in the late 1930s. In 1980, Margaret "Daisy" Suckley and three cousins deeded the site to the Rhinebeck Historical Society. (RHS.)

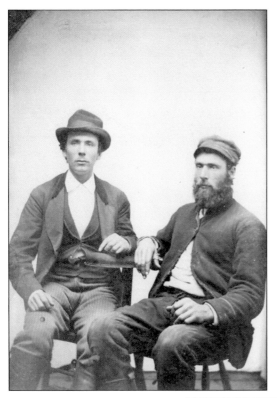

Brothers Isaac (1831–1901) and George (1842–1928) Kilmer pose in this c. 1870 tintype. The set is very simple—two chairs and a white sheet for a backdrop. At that time, the journey to a photographer's studio would have been a special event. In this case, the two brothers (local farmers) sent this tintype glued to a card as a Christmas present. (MRH.)

Before public water supply came to Rhinebeck in 1899, village residents needed to haul their water out of wells. A Mr. Day stands in front of a well covered with wire netting, which serves not only to keep out insects, but also discourages curious children from climbing in. Many older homes in the village still have wells, but health concerns prohibit connection to the house water supply. (MRH.)

William Kelly bought Ellerslie in 1841. Originally 800 acres, he later added another 800 acres to the property. In 1856, he was elected state senator. He joined with two partners in 1853 to incorporate what would become the First National Bank of Rhinebeck (today M&T). In the Panic of 1857, Kelly saved the bank with a personal note worth $14,000, making it among the very few in the state that never suspended specie payment. (MRH.)

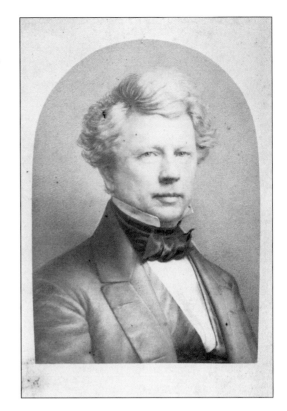

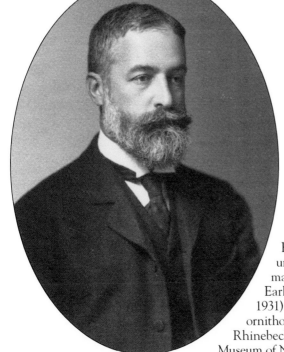

Ernest Crosby (1856–1907), state assemblyman (1887–1889) and judge of the Court of the First Instance at Alexandria, Egypt (1889–1894), was an advocate for universal peace. He was also a vegetarian. He made Grasmere his home in the 20th century. Early in life, his son Maunsell Crosby (1886–1931) was very interested in birds and studied ornithology until his death. Maunsell organized the Rhinebeck Bird Club and lectured at the American Museum of Natural History. (MRH.)

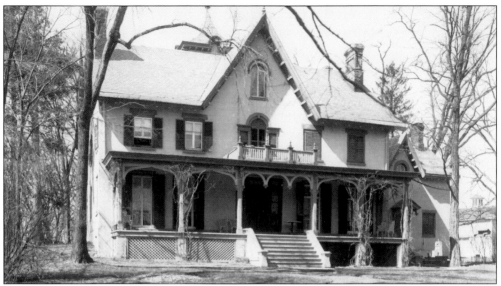

Pictured here around 1910, this house on West Market Street was the home of Eugene Wells (1839–1915). Wells had studied to become a physician but gave that up due to poor eyesight. He moved to Rhinebeck at the age of 26, became a director of the First National Bank, and served as president of the village. He married Mary Teller and had one daughter, Caroline Thorn Wells. (Photograph by Harry Coutant; MRH.)

This 1838 letter from Catherine Livingston Garrettson (1752–1849) is addressed to sister-in-law Louise Livingston. Catherine asks how Louise likes her minister and "if he's likely to be very useful." Very serious about her faith, Catherine wanted others to share that seriousness. She married Freeborn Garrettson and converted to Methodism despite her mother's demand that she stay away from both him and his church. (MRH.)

Two

RELIGION

Religion was an important part of life in Rhinebeck from its inception. The Dutch families of Kipsbergen crossed the Hudson to worship in Kingston. Although they had no church in Rhinebeck, they set aside land as their cemetery, which had the most magnificent view of the Catskills and the Rondout, from whence they came. The German Palatines built a church in 1716 at Wey's Corner, the junction of Routes 9 and 9G. It served both German Reformed and Lutheran congregations. Wind storm damage in 1802 destroyed the building. Only the cemetery remains. The German Reformed relocated to a new church in Red Hook. Meanwhile, Lutherans had built St. Peter's, better known as the "Stone Church," and St. Paul's, better known as the "Wurtemburg Church," at the north and south ends of town, respectively. Author of a widely used catechism, Rev. Dr. Frederick Quitman served both congregations and was one of the region's best-known ministers, conducting many of his services in German, a practice that lingered at the Wurtemburg Church until the early 20th century.

Meanwhile, the Dutch settlers of Kipsbergen joined residents of the village to establish a Reformed Church, starting with a house in 1733. The current church dates to 1808. A unique feature of the church is that brick walls face the roads, while stone walls face the cemetery. The Third Lutheran Church was established on Livingston Street, the Baptists on Montgomery Street, and the Methodists on East Market Street. The Episcopalians built initially on East Market Street but later sold that structure to the Catholics in order to construct more-impressive quarters on Montgomery Street. While the Catholics still had their mother church in Rhinecliff, other congregations established satellite chapels there, none that survive as churches.

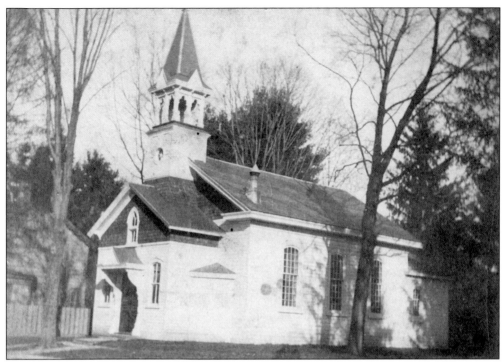

Rev. Robert Scott built the Baptist Church in 1825. A carpenter by trade, he came to Rhinebeck in 1796 at the urging of Margaret Beekman Livingston. He opened first a store, then a classical school, and was a teacher and surveyor for the rest of his life, all the while ministering to his congregation. As seen in the photograph above, the bell tower and vestibule were added to the original building in 1867 by William Kelly. After this photograph was taken, with funding provided by one of the oldest members of the New York Stock Exchange, Thomas Reed, the church expanded in 1890 on its south side to the corner of Livingston Street. The church is pictured below in 1941. (Above, photograph by J. Snyder, Rev. John Koppenaal, MRH; below, photograph by Frank Asher, MRH.)

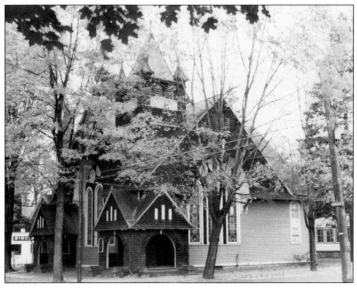

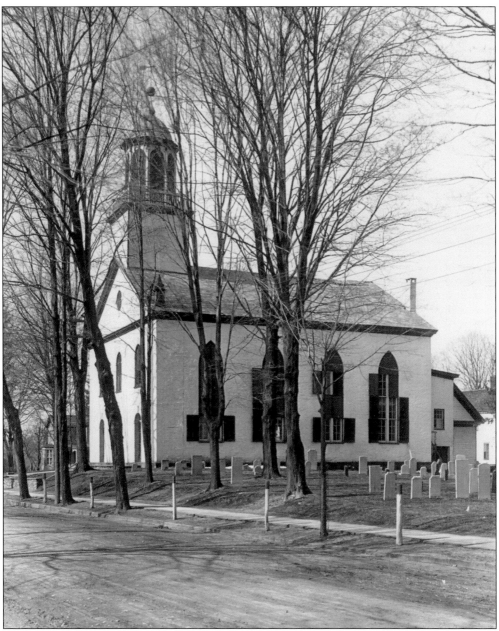

The Reformed Church appears little different today than in this c. 1919 photograph. The congregation may have held services here as early as 1733. When they finished this structure in 1808, it was still the only church in the village, counting Janet Montgomery, Philip Schuyler, and Gov. Morgan Lewis among its members. The graveyard is significant for its great number of Revolutionary War veterans. Individuals considering purchase of real estate in the core of the village of Rhinebeck are often puzzled to learn that the church owns most of the land south and east of the junction of East Market and Chestnut Streets, on which over 100 homes still stand, continuing to pay a nominal fee to the church pursuant to ancient agreements. The congregation recently restored the attractive steeple, and the church bell continues to announce the time for residents of the village. (Photograph by Harry Coutant; MRH.)

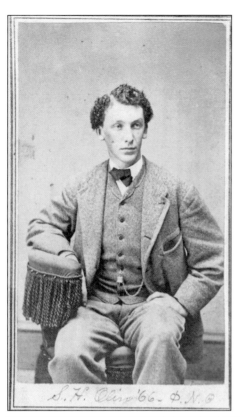

S. H. Olin '66. Φ.Ν.Θ

Stephen Henry Olin graduated from Wesleyan University in 1866, then went to law school in Albany and began practicing law in 1869, returning summers to the family home at Glenburn. He was a Wesleyan trustee from 1880 to 1925, serving as their president in 1922. His mother was a major proponent of the erection of the Hillside Methodist Church. (Photograph by E.P. Kellogg; MRH.)

The Methodists were newcomers to Rhinebeck, arriving with Rev. Freeborn Garrettson in 1792 when he came to visit his friend Dr. Thomas Tillotson at Linwood. Land donated by Janet Montgomery funded the church pictured here. An 1899 fire destroyed the building. Today, the Methodist Church occupies the site. (Photograph by Theo deLaporte; MRH.)

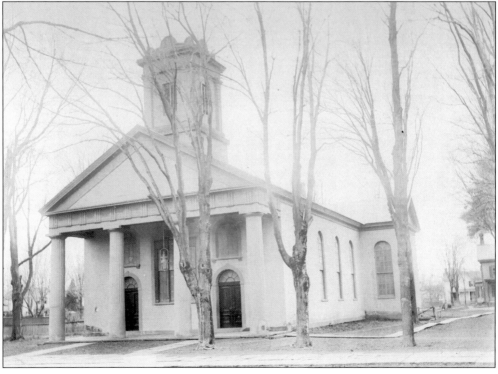

Reverend Dr. J. Howard Suydam, in 1897, served as pastor of the Dutch Reformed Church in Rhinebeck until 1903. In his 1909 book *Historic Old Rhinebeck*, Howard Morse says the church "comprehends in a surprising degree the old Dutch, sturdy, steady, hold-fast conservatism; it embodied in old times a spirit of progress that made things hum when they were set going." (Photograph by Theo deLaporte; Stella Hoff Tremper, MRH.)

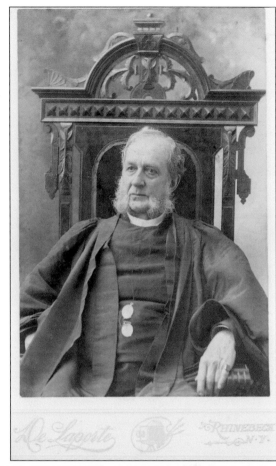

The Third Lutheran Church, at Center and Livingston Streets, suffered a devastating fire on July 10, 1909. The blaze was discovered at noon. By the time firemen arrived, the building was enveloped in flames. A nearby water cistern helped firemen keep flames from spreading to the adjacent parsonage and the DeGarmo Institute. The congregation rebuilt within a year, keeping the church's original appearance. (Robert Coonrod.)

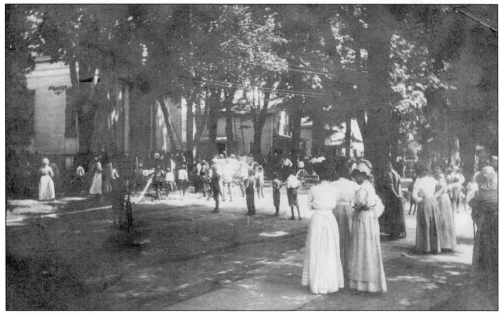

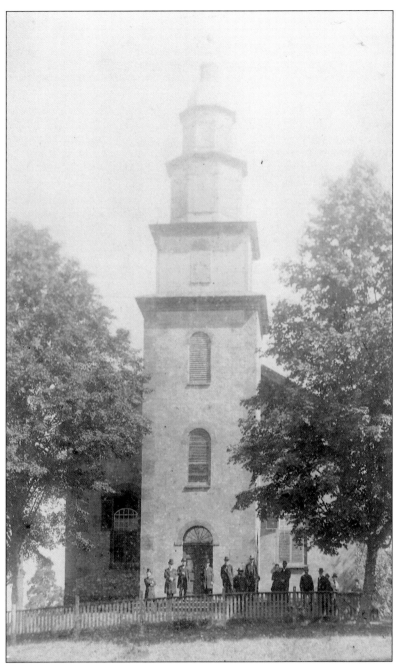

St. Peter's Lutheran Church on Route 9, just north of the intersection of Routes 9 and 9G, is the oldest remaining church in the town of Rhinebeck. It was built in 1786 around an original 1730 church. Receipts written in Dutch for glass, planks, and hinges—all from either 1730 or 1731 and paid for by Carl Neher—help date its construction. Neher died in 1733. Commonly referred to as the Stone Church, it was remodeled and enlarged in 1824 when the tall tower was added. Reverend Dr. Frederick Quitman served as minister here from 1798 until the 1830s. Minus the fence, it appears today much as it did in this c. 1890 photograph. The building continues to serve as a church. (Photograph by John Coumbe; MRH.)

Rev. William B. Sleep served as pastor of two of the smaller churches in the community, the Hillside Methodist Church, located across from Southlands on Route 9, and the Riverside Methodist Church in Rhinecliff. He served in that role from 1912 to 1916. Both buildings are still there. The former is currently vacant; the latter is a private home. (Photograph by Frederick A. Smith; MRH.)

Reverend Dr. Frederick Quitman was on his way home to Holland when President Washington persuaded him to stay in the United States because the new nation needed ministers of his caliber. Built in 1798, this parsonage attracted him to Rhinebeck's Stone Church. By 1929, the Quitman house had become a tourist home and was almost razed in 1974 before Marilyn and John Hatch led a local effort to preserve it. (MRH.)

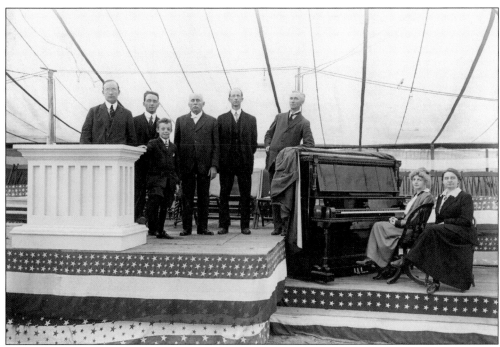

In the photograph above, evangelist Rodney "Gypsy" Smith, left, poses with, from left to right, Rev. William Boomhower (Wurtemburg Lutheran), Rev. Walter Miller (Third Lutheran), Rev. Merrick Bennett (Rhinebeck Methodist), and Rev. R.P. Ingersoll (First Baptist). Gypsy's ten-year-old son Jack and the pianist and accompanist were part of the traveling team. In the summer of 1915, three weeks of revival tent meetings were held next to the Methodist Church on East Market Street. The enormous tent is seen below. Thousands attended the meetings, an indication of both the popularity of the Protestant revival and Gypsy's national reputation. (Photographs by Ed Tibbals; MRH.)

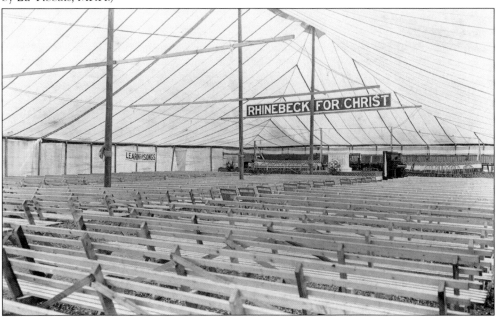

In the center of this lithograph, St. Joseph's Catholic Church in Rhinecliff served as the mother church in Dutchess County in 1881 for the following churches listed clockwise from the top left: Regina Coeli (Hyde Park), St. Paul's (Staatsburgh), St. Sylvia's (Tivoli), and Sacred Heart (Barrytown). Designed by George Veitch, St. Joseph's was built in the 1860s under Fr. Michael Scully. Until then, Catholics had to take a boat to Rondout to go to Mass. Father Scully bought land at Mulberry and Livingston Streets in 1862 with the intention of building a church in the village of Rhinebeck, but numerous Irish Catholic immigrants living in Rhinecliff objected so strenuously that Scully sold the Rhinebeck parcel. George Rogers of Tivoli then bought six acres in Rhinecliff from Charles Russell, gave the land to Scully, and by 1865, the church was finished. The village of Rhinebeck did not have its own Catholic church until 1903, when the Church of the Good Shepherd was established in the former Episcopal church. (Lithograph by Packard & Butler; MRH.)

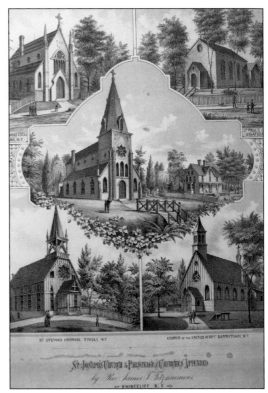

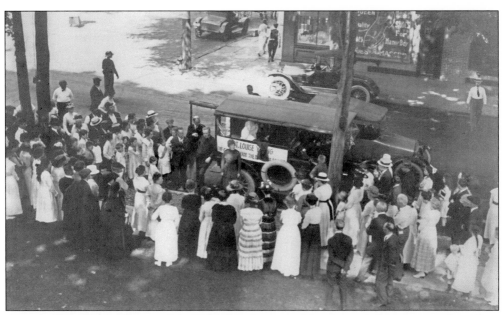

Aviatrix Capt. Louise Young of the Salvation Army is addressing mostly women at the village center in 1911. This was the women's march from Albany to New York City. The Salvation Army's mission is to take the gospel of Christ directly to the people, especially the poor, the homeless, the hungry, and the destitute, without using a church or pulpit. (MRH.)

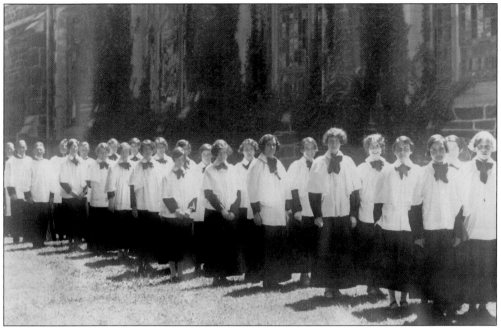

This 1926 photograph of the Episcopal Church of the Messiah women's choir shows the famous Tiffany stained-glass windows, donated by the wealthy parishioners. There was a boys' choir as well, most of whom came from out of town and boarded across the street from the church. Organist George Hull was also very well known. (Photograph by Frank Asher; MRH.)

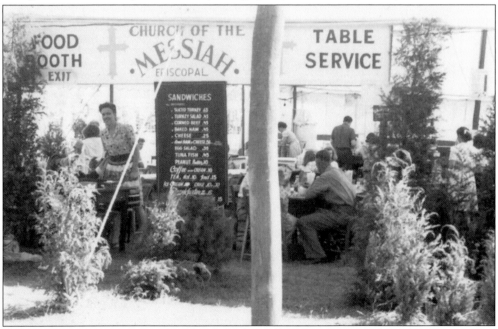

Pictured here in 1947, the Church of the Messiah food booth at the annual Dutchess County Fair raised substantial funds for the disadvantaged. The entire congregation pitched in to make the event a success, and the reasonably priced and delicious meals were very popular with fairgoers. (Photograph by Frank Asher; MRH.)

Three

FARMING

By the late 19th century, increasingly sophisticated threshers and hay presses allowed farmers (who could afford the equipment) to produce more in less time, although the engines and belts that drove the machines could lead to serious injury for the careless operator. Horses and oxen remained a mainstay for plowing and hauling loads, provided their owners kept the animals well fed and healthy. Tractors began appearing in the early decades of the 20th century, giving farm owners more time to devote to a myriad of other chores or to acquire additional land.

Alongside the smaller farms growing in the inland portion of Rhinebeck, the great estates, most of them on or close to the Hudson River, had farms of their own. Ellerslie and Ankony raised champion bulls that won prizes at national and international competitions. Ferncliff's orchards produced 15,000 bushels of apples and 500 buckets of maple sugar on an average year. Not to be outdone, a flower industry grew within the town that rivaled the agricultural achievements of the estates. Although the odor of natural fertilizer made the area repugnant to many during the outdoor growing season, the income more than made up for the discomfort. Violets and later anemones became symbols of Rhinebeck.

In 1900, Rhinebeck organized its own Grange chapter, providing support to those engaged in agricultural pursuits. A farmer just across the border in Pine Plains served as state and then national leader of the Grange during the Depression. In 1918, when the Dutchess County Fair moved to Rhinebeck after having migrated from Millbrook to Poughkeepsie, its future was uncertain. The fair is now the second largest in the state and has survived for almost a century.

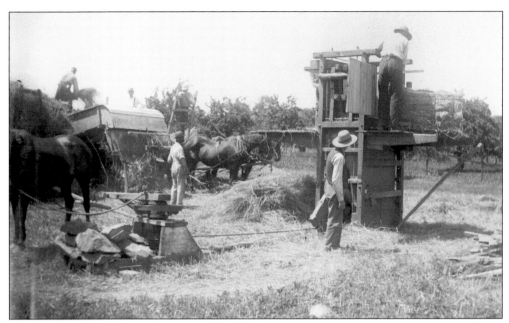

The boxlike contraption at the center right of this photograph is a hay press in operation at James Krom's farm, east of the village, around 1900. The equipment was stationary and required that hay be brought to it. It operated by a circular horse-powered winch, seen here weighted down with rock to assure stability. The bales it produced often weighed as much as 250 pounds but were relatively easy to stack. (RHS.)

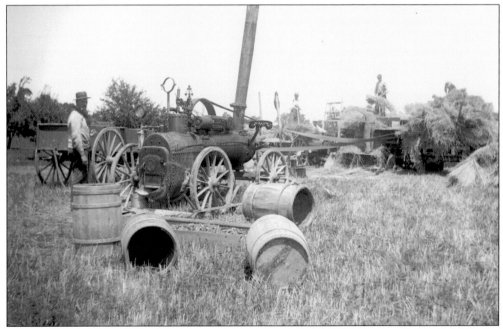

This steam-powered engine on James Krom's farm improved the efficiency of farm work but also added an element of danger. Coal was fed through the metal door into a burning chamber, water was poured into a boiling cauldron, and the belt powering the distant thrasher had to be kept on track. The man at left is most likely there to watch the temperature gauge. (RHS.)

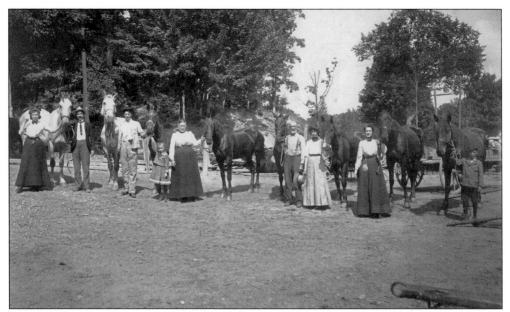

In this early-1900s photograph, nine people agreed to pose with these eight magnificent horses. With everyone dressed in his or her Sunday best, this is a testament to the important role horses played in a community as rural as Rhinebeck. (Photograph by Theo deLaporte, estate of Leroy Whitaker; MRH.)

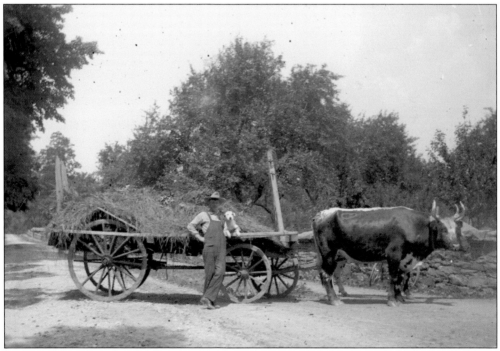

A pair of oxen drawing a hay wagon was slower and less efficient than horses for long-distance hauls but worked well for very heavy, short hauls. This load of hay appears relatively light. For a taller and heavier load, side planking would be attached to the four corner posts to prevent the load from slipping off on the bumpy roads. (RHS.)

Around 1895, Harry Goldsmith learned farming early, caring for baby chicks. As an adult, he raised violets at Silver Lake. But hauling them by horse and carriage to Rhinebeck took so much time that he sold his farm in 1923. He bought acreage closer to the village on Violet Hill Road, where he raised violets and dairy cows. He died in 1982 at the age of 92. (Catherine Hall.)

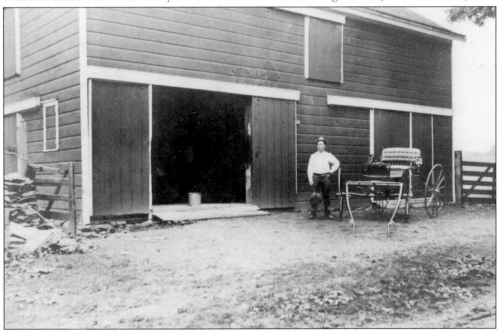

Clarence Traver, next to a new buckboard in front of a handsome barn, descended from generations of local farmers. Although the barn no longer stands, his Victorian home remains at the corner of Slate Quarry and Wurtemburg Roads. In addition to his work as a farmer, he also served as justice of the peace. Known as Judge Traver, he was an accomplished musician on both cornet and drum. (MRH.)

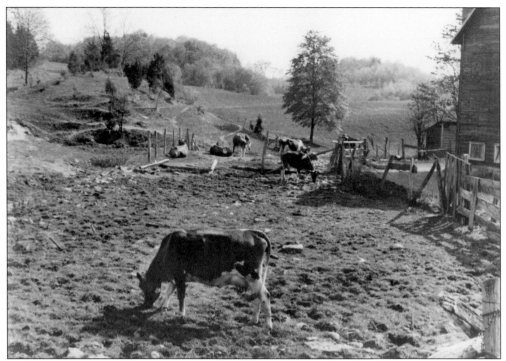

Pictured here in May 1941, the cows at the Welch–Proper–Lewis dairy farm have just returned from a pasture in the distance where they ate their fill most of the day. They are now doing a little final munching before being allowed back into the barn to be milked. Any rain made this part of the farm very muddy. The farm was off East Road and Salisbury Turnpike. (Photograph by Frank Asher; MRH.)

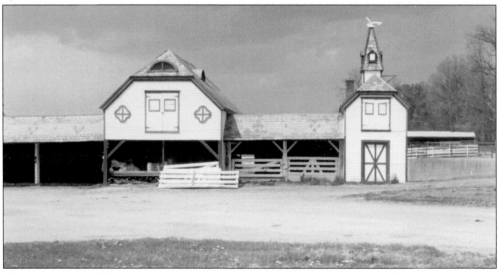

These original buildings remain at Ankony Farm, but the former owner's champion Angus are gone. The most impressive cattle from a herd that had been the darling of owner Sen. Allen A. Ryan Jr. took top prizes at international competitions. Their dispersal occurred at a 1962 auction that brought bidders from all over the world. Creed Ankony operates on this site today. (Photograph by Tom Daley; MRH.)

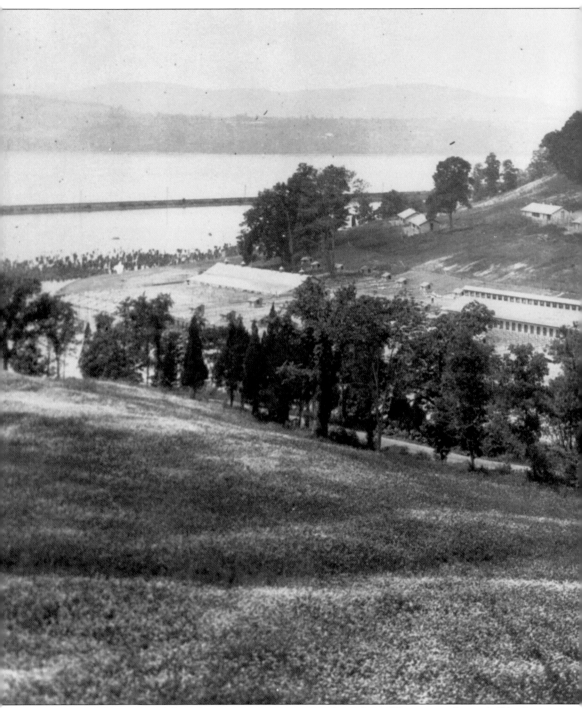

Linwood, like many of the other great estates, was a working farm. This view is from a hill looking northwest across the estate toward the Hudson River and the Catskills beyond. The mansion is not visible—it is on the highest point of land, beyond all the trees at right. Below the water tower are three poultry houses, and below those, the duck house is the longest building. Small sheds are for veal calves. The Landsman's Kill meanders just below the trees that are seen on either side

of the roadway, into Vanderburgh Cove, then through a few arched openings below the distant railroad tracks, and into the Hudson. Most of these buildings are gone. Today, the property serves as a retreat house for the Sisters of St. Ursula. (J. Ruppert Schalk Collection, RHS.)

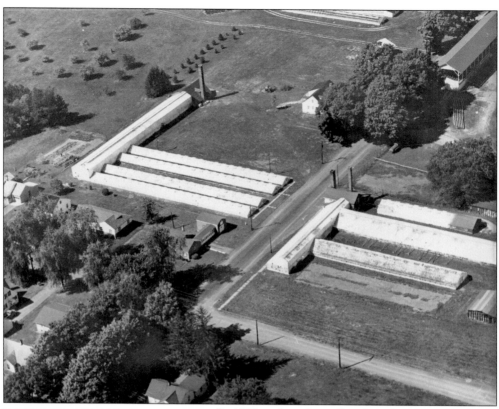

By 1907, violet sales in Dutchess County reached an annual high of over $1 million, making it the county's, and the town of Rhinebeck's, largest revenue source. By 1910, Rhinebeck counted 116 growers. Julius Von derLinden sold these greenhouses on Mulberry Street to Frank Trombini and sons in the 1940s. Gene Trombini was the village's last violet grower, closing in the 1970s. (Photograph by Henry DeWolf; Marcella Briggs, RHS.)

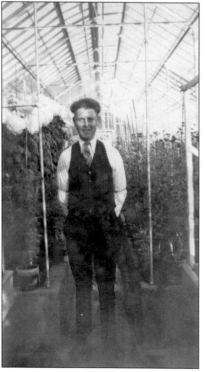

Pictured here at Ferncliff around 1925, Leland Atkins, gardener for the Astors, stands with pride among his plants, including enormous chrysanthemums to his right and possibly dahlias at his left. Estate gardeners were expected to provide a constant supply of cut flowers for the interior of the mansion and to make sure the gardens were a joy to the eyes of visitors and a source of pride to the owner. (MRH.)

Zingia Collier (in back) and Clara Balint posed inside the Goldsmith greenhouses on Violet Hill Road. Picking the flowers was very demanding. Because the delicate leaves were so easily bruised, workers had to lie on their stomachs on boards stretched horizontally above the flowers to pick them. (MRH.)

Seeding anemones requires patience, a good eye, and a strong back. In this c. 1950 photograph, Roswell Cole is planting anemone seeds in the loamy soil at Riverside Farms in Rhinecliff. Local growers went to anemones in 1936 after violets lost their popularity. Despite early success, the anemone industry in Rhinebeck has suffered from a variety of diseases that spread through many of the local greenhouses. (MRH.)

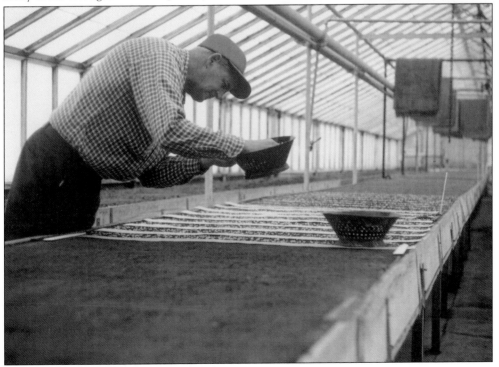

E. Wallace Lown is in his car in front of his family's business at East Market Street, on the east end of what today is the village parking lot, directly across from the Rhinebeck Fire Department. Lown's did a lot of business selling feed to local dairymen. At the time, one of his competitors, Herrick's, was directly across the street. (MRH.)

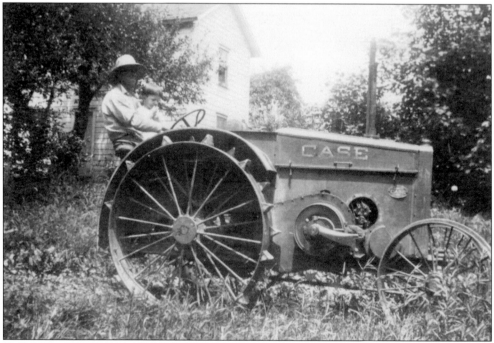

Herbert Gage owned a small family farm on Cedar Heights from 1914 until 1926. The metal studs on the chain-driven wheels improved traction and made this Case tractor a popular improvement in 1917 over horse-drawn equipment. Although the tractor was most useful for plowing or pulling heavy loads, in this case the owner seems to be using it just for family fun. (MRH.)

Although Rhinebeck today is known for its rural character, such views are almost gone. When this photograph was taken approximately 60 years ago, such scenes were so common that it is almost surprising that a photographer took the time to record it. Country lanes like this were everywhere. Trees at various stages of maturity and stone walls topped by crosshatch fencing contained livestock and marked property boundaries. (MRH.)

Jack Harrison proudly points to the height of the summer's corn. He is five-feet, four-inches tall in this 1930s photograph, and the corn is probably nine feet (half as tall as the barn), an indication that planting time was chosen perfectly and that the mix of sun and rain that year was also perfect. The Harrison Farm was located east of the village on Route 308. (MRH.)

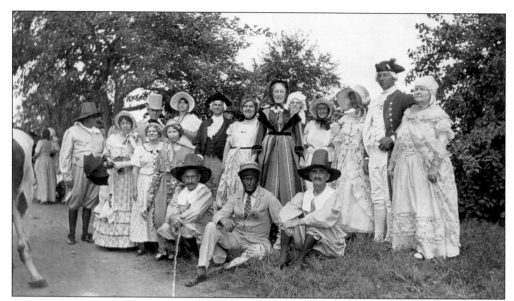

The Rhinebeck Grange enjoyed re-creating scenes from earlier times, which they called tableaux. Here, in the 1930s, they are re-creating a colonial event. Ethan A. Coon (1883–1952), known as the Violet King because of his national reputation for producing high-grade violets, is in blackface at center in the first row. The Grange was a social organization serving farmers and related professionals. The Rhinebeck branch was founded in 1900. (MRH.)

Rhinebeck's Grange, Patrons of Husbandry Chapter 896, first met in 1900 at Rhinebeck Town Hall, then above various businesses on East Market Street, then in Ethan A. Coon's packinghouse, and finally, in October 1940, they established their own building on Close Drive. Ethan Coon is at left. Behind him in a hat is Arthur Cozine, who donated the land. (Photograph by Edward J. Campeau; Catherine Hall, Rhinebeck Grange.)

Rose Kiely, at her Brookmeade house around 1935, pauses with hoe in hand while preparing her garden. The composition of the soil in Rhinebeck varies considerably. Brookmeade, close to the present Baptist Home, is full of rocks and bits of shale. The stand of grain growing behind her looks quite healthy, despite the conditions. (MRH.)

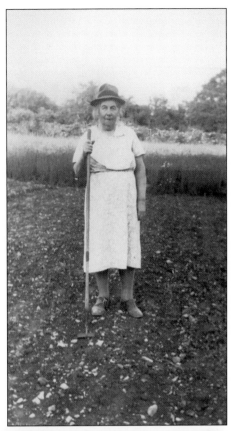

In November 1950, Rhinebeck Grange's 50th anniversary marked an important milestone. The evening concluded with entertainment. Involved are, from left to right, Paul Bahret (leaning backwards), Agnes Bahret, Thelma Sherwood, Gordon Denegar, and Ruth Ackert. Until the 1970s, Rhinebeck Grange met in this brick structure, built on Closs Drive in 1940. Today, it is a law office. (Photograph by Ralph Kohnert; Catherine Hall, Rhinebeck Grange.)

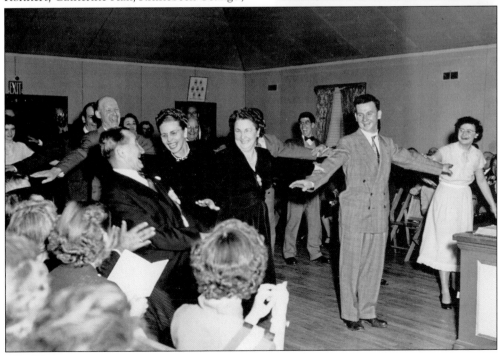

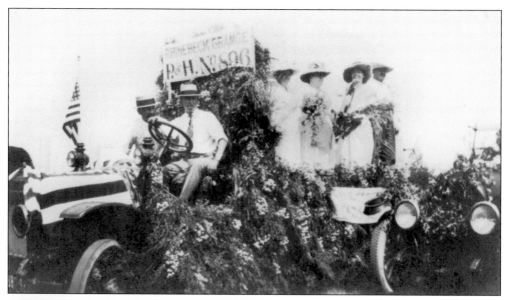

The Memorial Day parade has long been a big Rhinebeck event. Shown here in 1918, the local Patrons of Husbandry chapter seems to be especially enjoying their ride on this float. There were many flower growers in Rhinebeck at the time, and most growers were members of this organization, as a result of which this float would have drawn a lot of attention. (Catherine Hall, Rhinebeck Grange.)

The museum's archival records do not identify the woman washing dishes in this 1940 photograph. (Photograph by Frank Asher; MRH.)

It is hard to decide who is more of a dandy here, the man or his rooster. Today, the village of Rhinebeck's zoning code prohibits fully grown chickens on nonfarm lots. When this photograph was taken around 1919, however, a few chickens were not an unusual sight in a backyard enclosure. (MRH.)

When the Dutchess County Fair moved to Rhinebeck from Poughkeepsie in 1919, it brought many new visitors to the village. At this horse show in 1920, midget pony carts are competing in front of a sizable and very well-dressed audience in the left half of the photograph, while trotters in the background appear to be practicing for a later race. (MRH.)

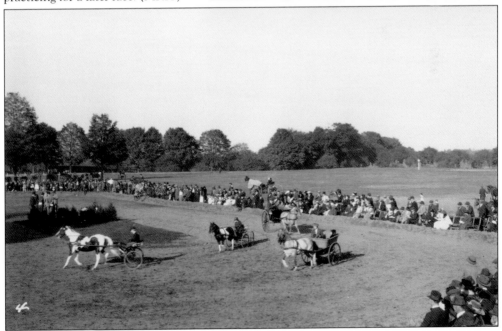

A welcome event, the Dutchess County Fair is the largest such event in the state, after the state fair. Regular admission was 50¢ in 1933, 50¢ more to sit in the grandstand, and 50¢ for auto admission, although parking was free at night. The fair still attracts enormous crowds, but contests for the cutest baby, horseshoe pitching, and wood chopping are no more. (MRH.)

Everyone knows to keep his or her distance from this bull being led through the grounds of the Dutchess County Fair around 1928. The boy behind the bull is standing ready with a prod in case the bull should move his way. (MRH.)

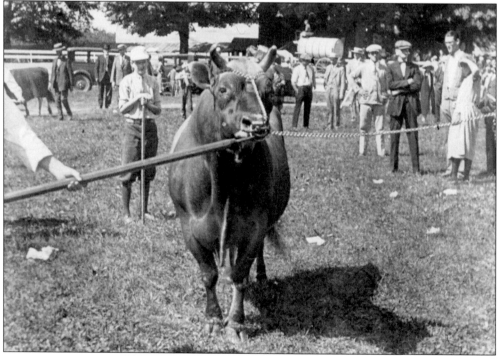

Four

COMMERCE

The village's commercial center has always been located at the crossing of Sepasco Trail and King's Highway. Beekman Arms was a stagecoach stop offering respite to travelers, while numerous livery stables, blacksmiths, and associated businesses catered to the needs of residents and travelers alike. At its peak, the Landsman's Kill counted 11 mills, none perhaps as important as Hogan's sawmill on the Albany Post Road. The furniture makers doubled as undertakers, while butchers, barbers, and beer producers provided the goods their customers needed. When the great estates grew, so did local commerce, as their managers came to rely on local merchants to meet their demands.

The fire of 1864 that caused such harm to Rhinebeck's commercial hub turned out to be its saving grace. Business leaders, such as William Carroll, recognized the need to build fireproof structures, and the legacy of brick buildings his colleagues left along the south side of East Market Street were very well planned and continue to be the most attractive and active commercial sites in the town.

At the town's southwest corner in the hamlet of Rhinecliff, the two catalysts for commerce were the river and the railroad. The development of numerous taverns was partly the result of the many travelers waiting for either the ferry or the train. Just as in the village, Rhinecliff saw the growth of stores selling dry goods, groceries, and provisions. Unique to Rhinecliff, however, was the development of the fishing industry. And Hog Bridge became the home of the coal, grain, and electric industries.

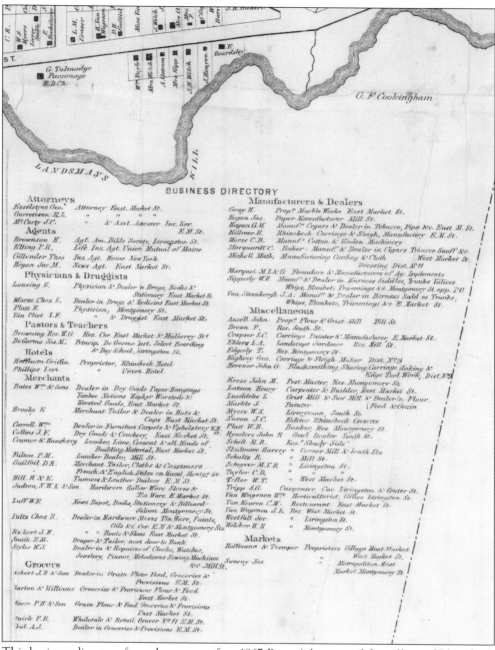

This business directory from the corner of an 1867 *Beers Atlas* map of the village of Rhinebeck catalogs the vibrancy of commerce in the community immediately after the Civil War. There were five grocers and two meat markets but only one restaurant (C.M. VanKeuren on East Market Street), a very different ratio than today. There are also two cigar manufacturers (G. Hogan and C. Marquardt) and numerous businesses supporting horse-drawn transportation but only three attorneys and three physicians. There were likely more businesses than are listed here. The *Beers Atlas* was an early version of the *Yellow Pages*—one had to pay a subscription fee to include a business name in the directory. The list is not comprehensive. There were numerous pastors, for example, but only one saw the need to advertise. (Teal Map Collection, RHS.)

46

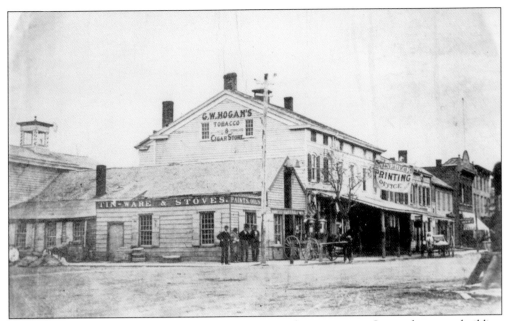

Looking east down Market Street from its intersection with Montgomery Street, the corner building had been a store and post office in 1790. A horse-drawn fire wagon stands sentinel, protecting what remains of the business district from a repeat of the 1864 fire that destroyed the unseen south side of the street. The wooden building was replaced in 1876 by the brick department store that stands there today. (MRH.)

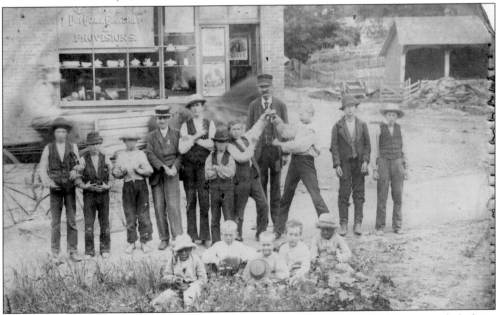

Ostrom & Cornwell is the backdrop for a variety of youths, some barefoot in tattered clothing and two who are intent on a fisticuffs display. The conductor seems unperturbed. The Rhinecliff station is downhill to the left. Frederick Cornwell started working for his brother-in -law H.D. Ostrom at the age of 14, eventually partnering with him to establish this general store in 1882. The building remains today. (MRH.)

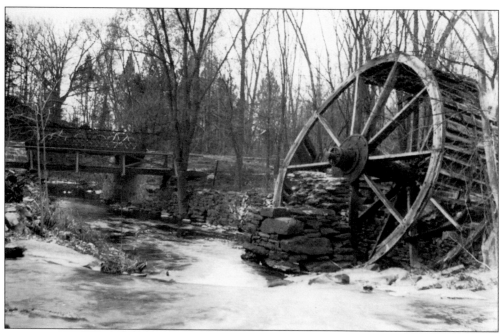

In the 1800s, this wheel powered James Hogan's sawmill, past which the Landsman's Kill flows under Route 9. Hogan had cut a channel from the south end of Crystal Lake, bypassing the dam to create a millrace that delivered a controlled flow on to the top of this wheel, then back into the stream. There were 11 mills on the stream. (Photograph by Frank Asher; MRH.)

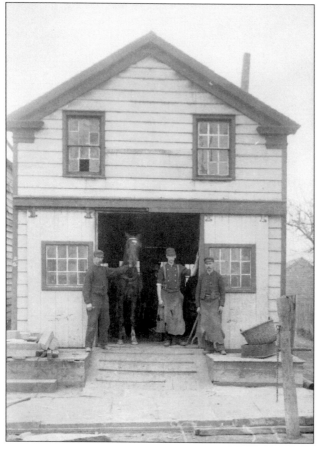

This 1880 photograph shows Milroy's blacksmith shop (horseshoeing was a specialty) on West Market Street near Oak Street. In 1874, John Milroy had formed a partnership with Monroe Kipp. Kipp dropped out after little more than a year, leaving Milroy to run the business alone until his brother Lafayette joined him in 1886. They sold the business in 1919, when John joined the automobile industry. (Photograph by E.W. Cook; MRH.)

After a fire destroyed much of the business district on May 8, 1864, William Carroll saw opportunity and moved his cabinet making business to a three-story building he erected at 22 East Market Street. He also made coffins and served as an occasional mortician, and legend has it that it was he who prepared President Lincoln's body for viewing in Albany, when the funeral train stopped in Rhinecliff. (MRH.)

This 1918 photograph of a World War I bond rally shows the Montgomery Street businesses. The businesses are, from left to right, "white corner" (apparently so-called because of the building's whitewashed appearance); followed by two wood-sided structures that would soon be converted into Patterson's Ford; then a taller building (with an awning), which is Foster's Restaurant today; and finally a portion of the Starr Building. (Gubler Collection, MRH.)

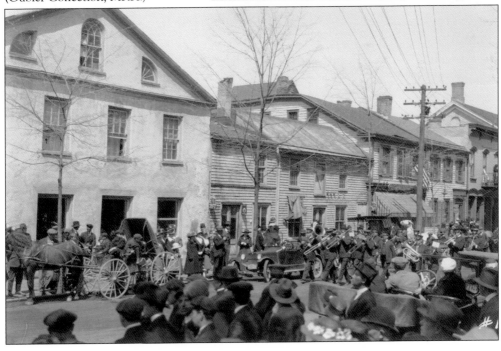

Pictured here around 1913, the Rhinebeck Hotel was the place to be in Rhinebeck regardless of the public event. Located at the hub of commerce, it had already served as an important stagecoach stop for over 200 years by 1913 and was just starting to attract motorists who were eager to drive to the self-appointed "oldest hotel in America." (MRH.)

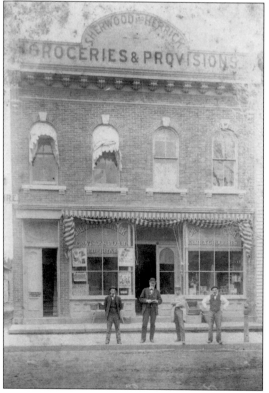

Frank Herrick came to Rhinebeck in 1875 to clerk for the Sherwood brothers, leading grocers here at the time. When Isaac Sherwood died in 1881, Frank was taken into the firm, and it became Sherwood and Herrick, seen here at 15 East Market Street around 1885. In 1892, Philo Sherwood retired, and Herrick moved the business to the site of today's Village Hall. (Photograph by E. W. Cook; MRH.)

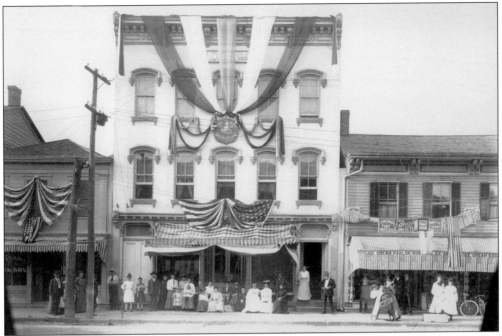

The crowds are staking out the best seats for the Memorial Day parade in front of the Independent Order of Odd Fellows (IOOF) building. The Rhinebeck branch of the IOOF, founded in 1845, had as their mission to visit the sick, bury the dead, educate orphans, and protect widows. It remains one of the most elegantly constructed and sturdiest buildings on the north side of East Market Street. (MRH.)

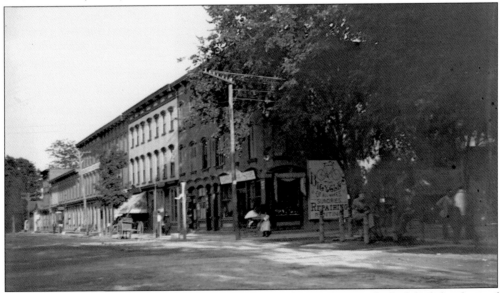

In the shaded area on the right, men are relaxing at the town pump, which slaked the thirst of horses pausing on their journey through the four corners at the center of Rhinebeck. The posts serve the dual purpose of protecting the pump from damage by a vehicle and as hitching posts for horses. The brick buildings in the foreground along East Market Street look much as they do today. (RHS.)

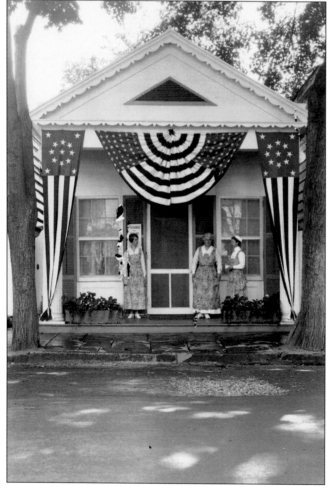

Between 1890 and 1940, Jacob Pindar was one of the best-known local shad fishermen. He used this gas-powered boat to tow his colleagues to and from the fishing ground, when Rhinebeck's shad fishermen were among the largest suppliers to the New York City markets. He lived at a riverbank house in Rhinecliff near his boat. The tunnel in the distance at right is the Astor tunnel. (Kay Verrilli, MRH.)

The Women's Exchange, established by Alice Dows, her daughter Laura Delano, and Elizabeth Lynch, encouraged fair trade by women of items made by women. Eleanor Roosevelt was among their supporters. She visited several times when she was in Rhinebeck, and she wrote laudatory articles about the exchange in a weekly newspaper column. In this c. 1918 photograph, three women are waiting for a parade. (Gubler Collection, MRH.)

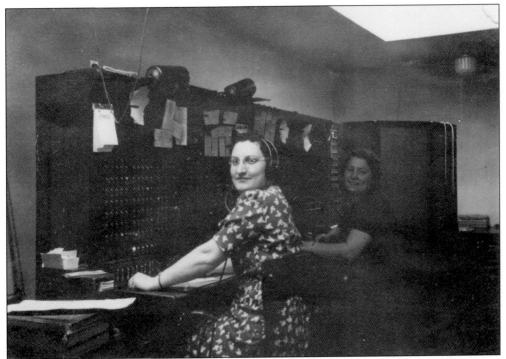

Minerva Bravender (left) and a colleague are switchboard operators for the Red Hook Telephone Company in 1939. Located across from the Beekman Arms since the early 1900s, the company continued to serve northern Dutchess County until the 1970s, absorbed first by Continental and eventually Frontier. In 1939, local calls went through this manual switchboard. The efficiency of the telephone system depended on alert and quick-handed operators. (MRH.)

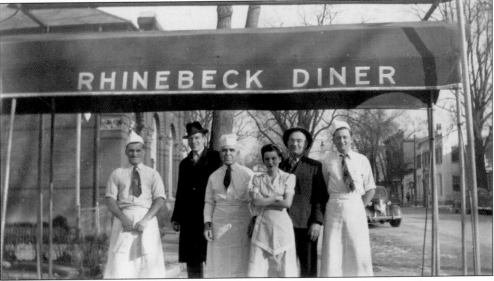

Tony Djinis, third from left, was the owner and chef of the Rhinebeck Diner, a local institution in 1944. The diner was just south of the First National Bank (today's M&T Bank). The meals were simple and inexpensive, and the service was quick and efficient. The diner is no longer there; it has been replaced by an office building. (The Hull family, MRH.)

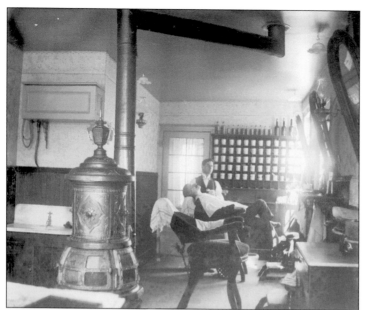

A shave at Martin Deichelman's Barber Shop on West Market Street was a ritual for many men in town. The four-dozen mugs hanging on the rack at the entrance would each have been reserved for one of the regulars. The stove was a fixture in most businesses, and this one is very elegant. The protective glass covers above the oil lamps prevented smoke residue on the ceiling. (RHS.)

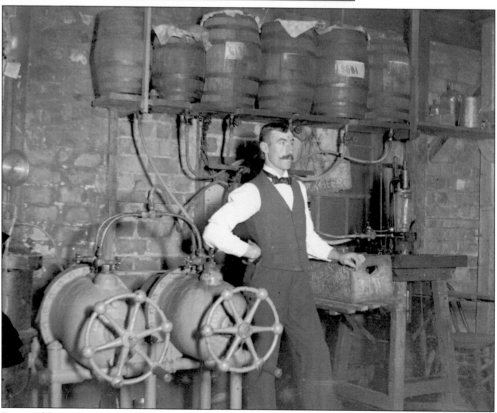

Pictured here around 1915, this beer-making operation seems to be limited to birch and ginger beer. The overhead barrels, valves, vats, and gauges all seem quite complicated. The gentleman in the photograph is most likely the master mixer. Many of the basement walls of the older buildings in the business district still look like this, but it is not known where this is. (RHS.)

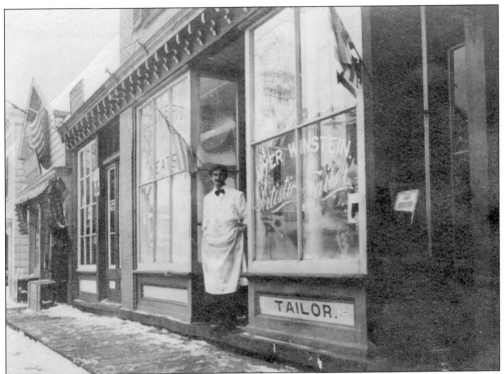

Henry Schaad, standing at 40 East Market Street around 1918, grew up wanting only to work with horses. He loved transporting people and violets to the railroad station in a stagecoach. His mother insisted he learn a trade, so he became a butcher, eventually buying the business from Frank Rikert in 1922. It remained a meat market through the 1960s. (The Schaad family.)

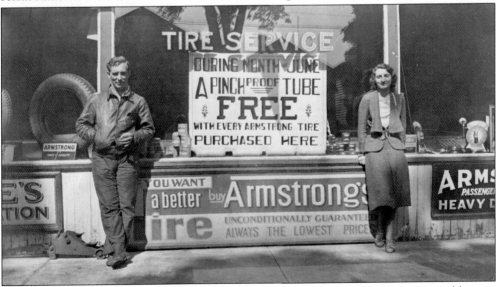

George and his wife, Minerva Bravender, operated the Armstrong Tire Shop, pictured here in 1932, replacing Patterson's Ford Garage. The location is just south of Foster's Restaurant. The building was subsequently razed, and an Esso gas station occupied the premises. It too was later razed, and today the site serves as an outdoor seating space and parking lot for Foster's. (MRH.)

Boarding Houses

in and near Rhinebeck
Dutchess County
New York

Rhinebeck

The Village of Rhinebeck is 205 feet above sea level; population 1,520; ten miles of streets, the village of homes and business combined; the parlor of Dutchess county and the vacation spot for hundreds of city people. Every corner of Rhinebeck is a beauty spot. The village public square is located at 41 deg. 55 min. 36 sec. North Latitude and 73 deg. 54 min. 47 sec. West Longitude.

Rhinebeck has paved streets, two banks, six churches, Starr Institute, the Northern Dutchess Health Service Center, a well equipped hospital; Holiday Farm, a home for convalescent children given by Vincent Astor; the oldest hotel in America; day and night electric light and power service, pure water in plenty, one motion picture theatre, adequate schools and fire protection, good public library, taxicab service and night watch service. The Rhinebeck Gazette is the local weekly newspaper, a model rural paper, now in its ninety-fourth year of publication.

Rhinebeck is the center of the violet growing industry and supplies all markets east of the Mississippi river with blooms; one railroad passes through the town limits, the New York Central and the service is the best.

Visitors return here year after year because they find the Boarding Houses and Inns comfortable, clean, with excellent food, amid attractive surroundings of shade trees, lawns, lovely gardens and nearby lakes and streams. Within a few miles is an excellent golf course.

Boardinghouses were a big business in Rhinebeck between World Wars I and II. This brochure from 1940 describes Rhinebeck as "the parlor of Dutchess County and the vacation spot for hundreds of city people." Herminella Island finds it necessary to mention that there are innerspring mattresses on all the beds, implying that is not the case elsewhere. At Shady Lake Farm, there was "a boat for every room." People came for a day, week, or summer, and some would return years later to settle in the area. Note anti-Semitic boardinghouses limited their clientele to "Gentiles" or "a refined class of Christian guests." (MRH.)

MRS. T. K. MARTIN—Tourists Home

Route 308, within walking distance of village. All Modern improvements. Meals optional. Open all year.

WALLY FOSTER'S VILLAGE TAVERN

Licensed Restaurant
Beer Garden Dancing
Montgomery Street, Rhinebeck, N. Y. Phone 288

BEEKMAN ARMS

The Oldest Hotel In America
Rooms — Restaurant — Tap Room
Booklet and Rates on request
Telephone 80 L. F. Winne, Proprietor.
Rhinebeck, N. Y.

LOCUST GROVE INN

Quiet, restful, completely modern, private baths. On hill with fine view, edge of village, 3 minutes walk to center. Excellent meals. $18.00 to $25.00. Gentiles.
Telephone 171-M, Rhinebeck, N. Y.

SHADY LAKE FARM

Rhinebeck, New York, Box A.
80 miles from New York. American plan. Accommodates 60. Catering to a refined class of Christian guests. Boating, bathing, fishing, lawn bowling, small golf, croquet, quoits, swings, hammocks, lawn showers, sun bathing, bridge, cards, chess, checkers, amateur shows, dance hall, radios, pianos, etc., furnished free to guests. Boat for every room if desired.

Rates $14.00 to $16.00 weekly. Illustrated booklet.

SPRINGBROOK HOUSE

On Albany Post road, route 9, at northern edge of village, adjoining Dutchess County Fair Grounds. Five minutes walk to center of village. All modern improvements. Excellent meals. Tourists—day, week or season. $12.00 to $14.00 per week.
Mrs. William Hansen, Jr. Telephone 188-R, Rhinebeck

COLONIAL COTTAGE

Montgomery Street, Rhinebeck, N. Y.
Tourists and Permanent Guests. Rooms
All modern conveniences.
Mrs. William Gulliver, Manager. Phone 220-W

HERMINELLA ISLAND

Home for tourists, on route 308 at eastern end of village. A fine large colonial house with lawns, shade and pretty stream. Innerspring mattresses on all beds. Meals served. Special rates by week or longer.
Mrs. Hervey E. Kilmer. Phone 209-F3

Modern country resort; seclusive; spacious lawns, complete vacation on grounds. Amusements, official clay tennis court, recreation hall. Own farm products, every comfort. Large, airy corner rooms with or without running water. All rooms adjoin or are just a step from bath and shower. Suites with private bath and shower. $15.00 - $18.00 including all costs, amusements, tennis, etc. Gentile. Barrytown road one-eighth mile from Rhinebeck village.
Mrs. E. A. Staley, Prop. Tel. 529-F3 Rhinebeck, N. Y.

RM.2004.260.4.

56

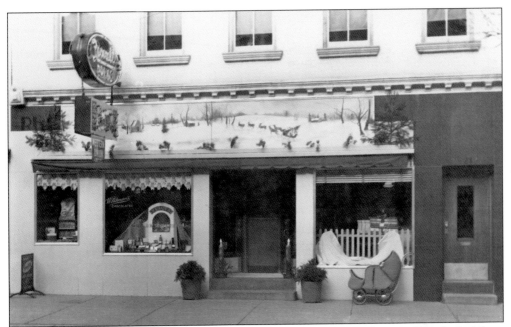

In the 1940s, the Schermerhorn Building at 19 East Market Street is decorated for the holidays. Previously known as the Independent Order of Odd Fellows building and then the Judson Building, Schemmy's was a drugstore, soda fountain, toiletry shop, and the place from which to send a Western Union telegram. The Art Deco facade has since been removed and the building restored to its original appearance. (MRH.)

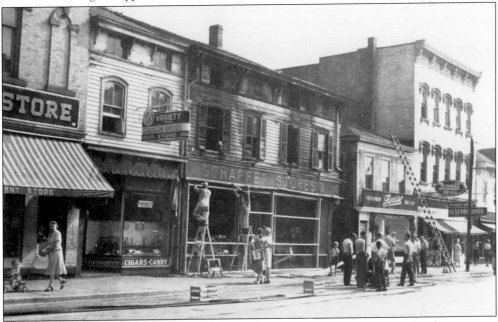

Part of a chain of grocery stores, Shaffer Stores closed after this 1948 fire, miraculously sparing its neighbors. After the building was razed, Janice and Al Stickle moved from their former location (today the Rhinebeck Bank parking lot) and constructed a new one-story building on this site. Stickle's serves today as a popular variety store; it is still run by the Stickle family. (MRH.)

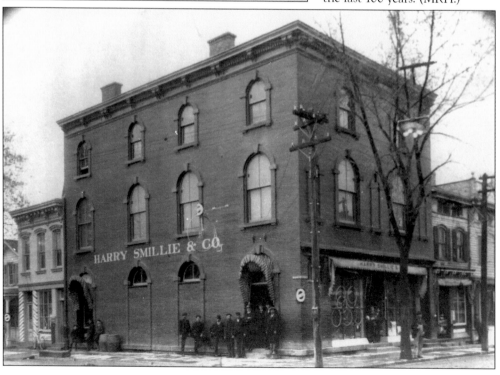

The author of this May 1835 letter, Edward Livingston, would die within a year, and his wife would sell all of his Rhinebeck lands to a group of six individuals. One of the six was Rhinebeck attorney William B. Platt, to whom this letter is addressed. Livingston is asking Platt to handle his Rhinebeck affairs and more specifically to negotiate a financial matter with Rutsen Suckley on his behalf. (MRH.)

Bicycles are hanging in the front windows at Harry Smillie and Company. Prominently commanding the northeast corner of the village's main intersection in 1900, the business would expand to take over an adjacent shop to the north. Except for some changes in doors and windows, the building has remained unchanged in the last 100 years. (MRH.)

HARRY SMILLIE & CO.

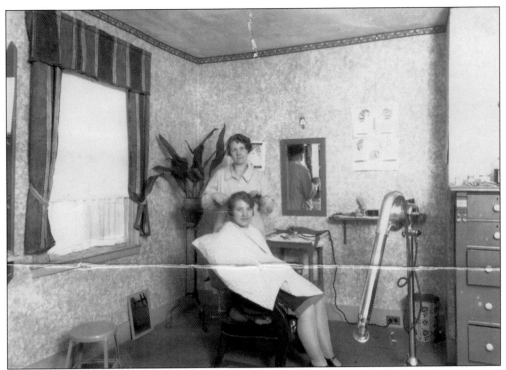

Elizabeth McKee ran this beauty shop around 1931. Her sister Eva Ruhland is in the chair receiving one of the "American Styles" shown in the wall poster. The location is Elizabeth's home on Montgomery Street, today an outdoor dining area at Foster's. The shop featured an industrial-size hair dryer and was the first such business in Rhinebeck. It operated for 45 years. (MRH.)

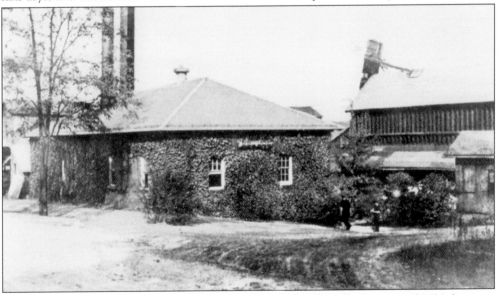

The Power and Light building, located on the village side of Hog Bridge around 1930, long ago ceased to provide electricity. With the coal-fed power plant providing electricity, Rhinebeck was ahead of many other communities of comparable size early in the first decade of the 20th century. (Steven and Nellie Wojehowski, MRH.)

The *Rhinebeck Gazette* had been a successful business since 1846. The logo of a cat intrigued by a small insect weighing down a flower and tail swirling below appeared in Tracy Hester's column in the 1910s. Like many other businesses of the day, the newspaper gave away calendars as promotional items, and they hung in many local shops and homes. Michael Strong was editor of the newspaper in 1962. (MRH.)

The large building on the right is the Beverwyck Inn, which is facing Schatzell Avenue in Rhinecliff as workers dig up the south side of the street. J. Bride Groceries, the lighter-colored building in the center, later had to be removed to make way for the triangle now in the center of the hamlet. (Carole Morris, MRH.)

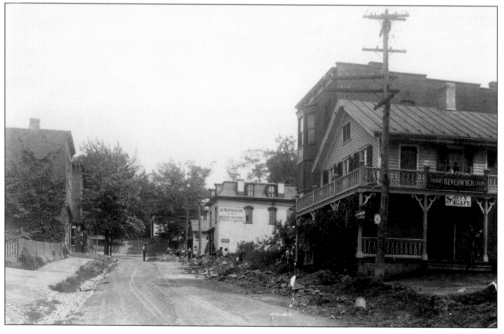

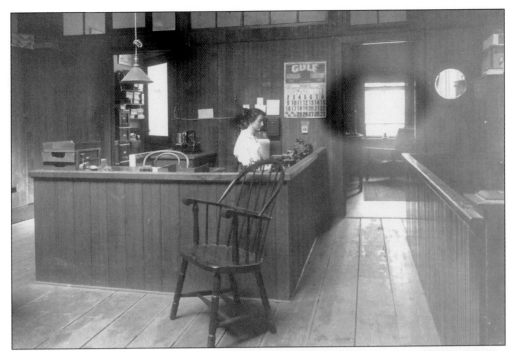

Pictured here on March 15, 1919, this is the reception area of the *Rhinebeck Gazette*. R. Raymond Rikert ran the *Rhinebeck Gazette* from 1893 until 1906, when Jacob Strong bought it. Strong improved the quality of the paper, receiving a prize in 1925 from the National Editorial Association for best editorial page in the United States. (Photograph by Harry Coutant; MRH.)

This 1930 portrait shows Jacob "Jake" H. Strong Jr., who inherited the *Rhinebeck Gazette* from his father and in turn passed it to Michael J. Strong in the 1960s. Ownership later passed to Hamilton Meserve. The newspaper became part of *Taconic Press* in the 1980s with several other small-town newspapers of Dutchess and Putnam Counties. The group declared bankruptcy in 2009, and Rhinebeck lost a tradition of 163 years of weekly news. (Eleanor Strong, MRH.)

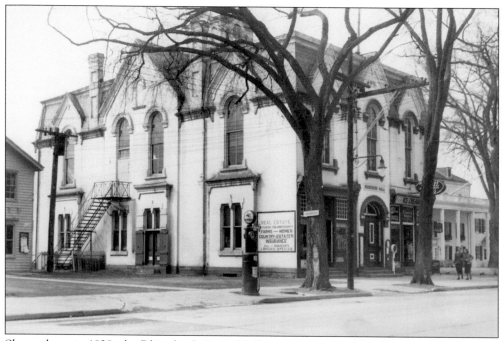

Shown here in 1938, the Rhinebeck Town Hall was an enormous building. It would shortly be torn down to make way for the new post office. Behind two pedestrians is the Beekman Arms. Inside the town hall were an ice cream parlor and drugstore, Applegate Real Estate and Insurance, and the town jail. The upstairs doubled as theater and gymnasium. (Photograph by Frank Asher; MRH.)

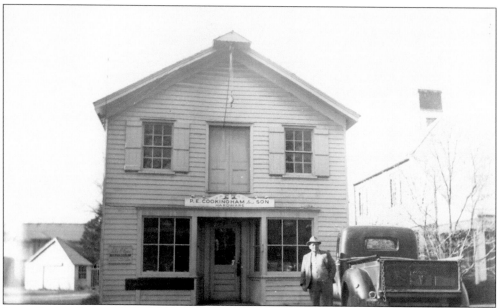

Pierre Cookingham stands in front of his hardware store in 1944. Later the John B. Kane Insurance office, the store sits just south of the new post office. This is one of 40 photographs in a scrapbook sent to George H. Hull during World War II as a Christmas gift. Hull's wife went to her husband's acquaintances to ask them to pose for the album. (The Hull family, MRH.)

Five

TRANSPORTATION

The Hudson River had long served Native Americans as a means of transportation. The Kip brothers were among the earliest Dutch settlers who established a ferry service, capitalizing on the demand for a predictable means of conveyance across the river. The ferry remained in operation until the mid-20th century, when it was replaced by the Kingston-Rhinecliff Bridge.

After the end of the Civil War, Rhinebeck's streets were filled with horse-drawn vehicles, and the town witnessed the growth of livery stables, blacksmith shops, and feed stores that would cater to their needs. Bicycles were used as much for leisure as for transportation. Smillie's served this clientele at a prominent site in the middle of the village that is today's Rhinebeck Department Store. When automobiles and trucks started showing up, admiration for these new contraptions led to wider use when their cost became more reasonable. Citizens who had always demanded good roads were now even more adamant. The *Rhinebeck Gazette* noted in his obituary that four-term supervisor John C. Milroy's most noteworthy accomplishment was buying a stone crusher in 1886. Highway superintendent Charles Staley welcomed the accolades when he accepted the first steamroller 20 years later.

The arrival of the railroad, just before the Civil War, had the greatest impact on the community. Railroad workers settled in Rhinecliff, and trains brought visitors. Many were just pausing while waiting for a ferry to Kingston and the Catskills, while others lingered, a good number eventually returning to settle in the area. The nation's largest city was now reachable within a few hours, and while some saw Rhinebeck's rural character threatened, violet growers, hoteliers, and merchants rejoiced.

Rates of Ferrage across North River – viz

			Cents
1 Waggon & 2 Horses & Driver Loaded		8/	75
1 Do — & Do empty		6/	56
1 Chair & Horse & Driver		3/	31
1 Man & Horse		2/	19
2 Men & 2 Horses 1/6 each	12 1/2 each	3/	25
1 Man 1/ 2 men or more 9ᵈ ea	12 1/2 or 10 Cents		
1 Yoke of Oxen & Cart & Driver		6/	75
1 Do Loaded		8/	80 1/2
1 Yoke of Oxen & Driver	3/ 37 1/2	0/	
all neats Cattle pr Head	1/	0	12 1/2
Sheep pr Head		2	2
Hogs pr Head		3	3
A Drove of Horses pr Head		9	9
All empty Casks and a } one Cent		1	1
Bushel of Grain Salt &c }			
Shingles 4/ M. Boards 4/ M. feet 50 Cents each			
A Barrel of Flour & } 8 Cents		8	8
Cyder Spirits &c			

Rates across Rondout Cats kill &c &c

1. Waggon & 2 Horses & Driver 19 Cents		1/6	12 1/2
1. Chair & Horses & Driver 12 1/2		1/	9
1. Man & Horse 6		6ᵈ	4
1 Man 4		4	3
all neat Cattle pr Head 4		4ᵈ	3
1 Yoke of Oxen Cart & Driver 19		1/6	12 1/2
Sheep & Hogs pr Head 2		2	2
all empty Casks pr Doz 6		6ᵈ	6
a Wt of Grain or Salt &c - 1		1	1
a Bbl of Flour Cyder &c 1		1ᵈ	1

& from the beginning of the Season to the first May & from the 20 of Novr to the close of the Season, 1/4 more in addition to the above rates —

On August 5, 1752, Jacob Kipp and Moses Cantine received government approval to operate a ferry between Kingston and Rhinecliff forever, with competition forbidden within two miles on either side. The government additionally required any ferry operator to sign an agreement to pay a fine if he exceeded the rates of ferrage (see above). (Archives of the Ulster County clerk's office, Kingston, New York; Nina Postupack, Ulster County clerk.)

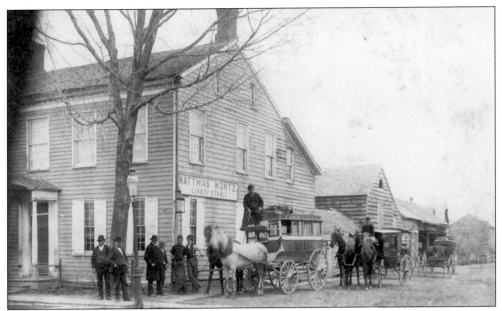

Matthias Wortz's Livery Stable preceded Fraleigh's at 24 West Market Street. The large front coach had to carry customers and their luggage to or from the busy Rhinebeck Hotel (known since 1917 as the Beekman Arms). The most common destination would have been the railroad station and ferry stop in Rhinecliff. Wortz also rented single and double turnouts for weddings, parties, and funerals. (Photograph by E.W. Cook; MRH.)

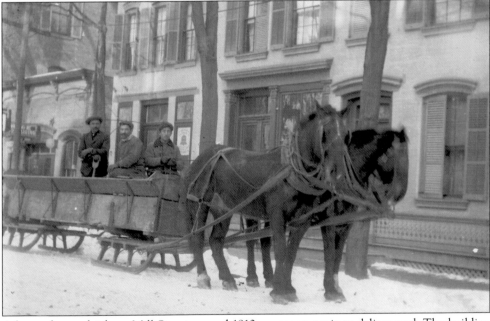

A horse-drawn sleigh on Mill Street around 1910 pauses on a trip to deliver coal. The building behind the sleigh houses the Red Hook Telephone Company. Eventually, the telephone company would tear down this building and replace it with a more contemporary structure. Today, it houses a theater and several storefront businesses. This pair of draft horses and three men appear to be accustomed to strenuous work. (RHS.)

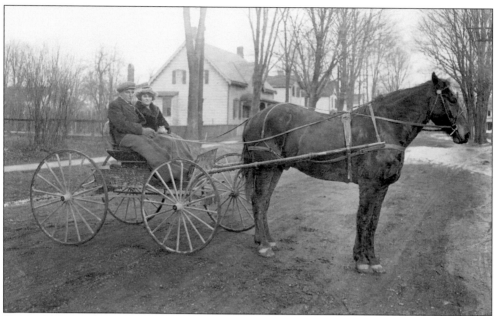

On a cold day in the late 1910s, a heavy blanket made travel a little more tolerable for this young couple. Even though cars were being sold in Rhinebeck, the horse-drawn carriage remained the most common form of transportation for a long time. (Photograph by V.W. Shaffer; Gubler collection, MRH.)

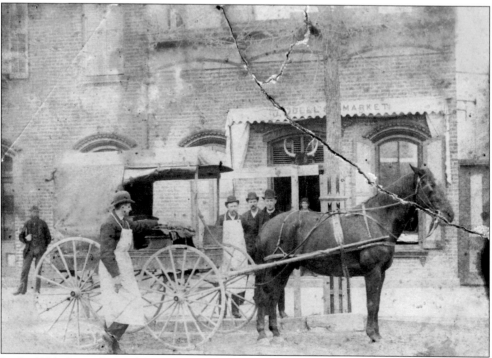

In the 1890s, horse-drawn delivery wagons played an important role in supporting local commerce. Odell's Market was located on the south side of East Market Street in the village. The steer's horns over the entrance may be an indication that the store sells meat. (MRH.)

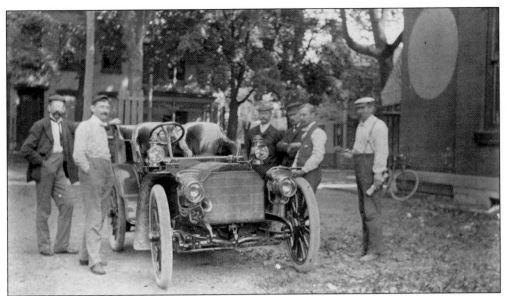

Always an attraction, an Astor car is parked just north of town hall, seen at right. Vincent Astor enjoyed driving on local roads, often at high speed. Admiring the car are, from left to right, George Tremper Sr., Alex Leans, William A. Traver, George Tremper Jr., Julius Von der Linden, and Judson Odell. At left across Mill Street is the Red Hook Telephone Company building. Note the absence of traffic. (MRH.)

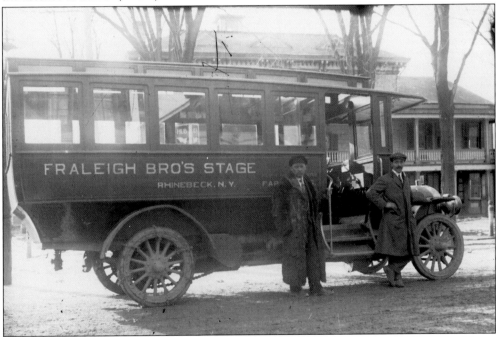

John H. and Frank J. Fraleigh operated Fraleigh Brothers, a livery exchange and horse stables at Garden and West Market Streets. Keeping up with transportation changes, they replaced their horse-drawn coaches between Rhinecliff and the village with this chain-driven motorized bus, parked here outside the Hub Garage. When the business was discontinued after 14 years, John started a general trucking business, which he kept up until his death in 1937. (RHS.)

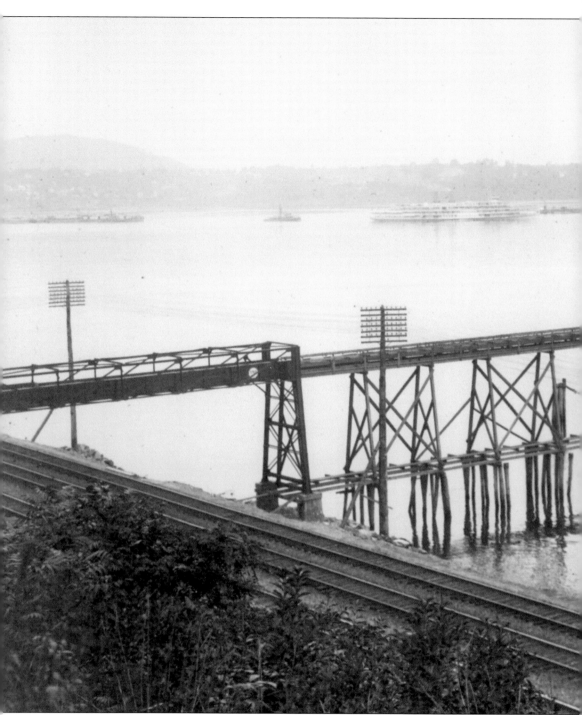

The trestle extending out over the New York Central tracks had to go well out into the river to reach a point where the river was of sufficient depth to allow cargo ships to tie up, take on a load, and still have enough draft to avoid running aground under full load. The Rondout Creek and the Hudson River dayliner *Hendrick Hudson* are barely visible in the background. The three-masted schooner is loading moulding sand at Rhinecliff in June 1914 to take to Halifax, Nova Scotia. An

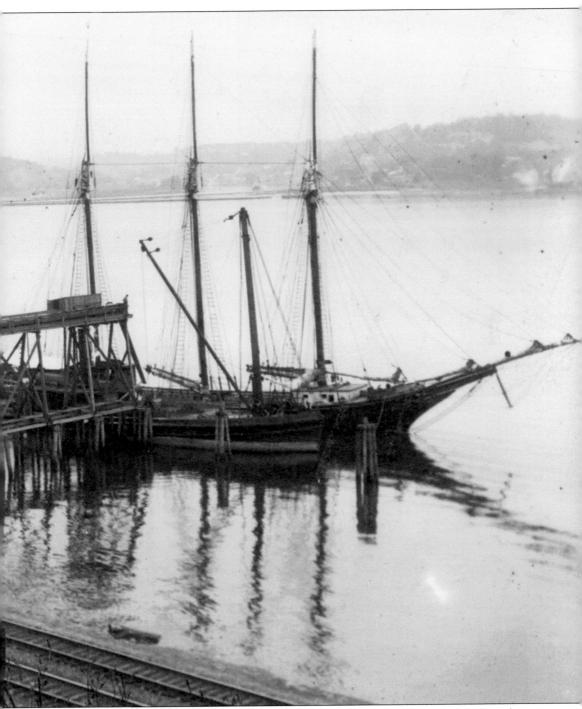

electric-powered conveyor belt moves the sand from the sand banks, owned by Pettinos Brothers, near the old Kip–Beekman–Heermance house and deposits it at the rate of 65 tons an hour into the schooner. The White Head Sand Company and Bottina Sand also shipped local sand from Slate Dock. (Don Cole, MRH.)

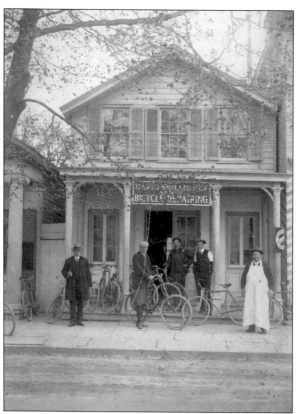

Harrie Smillie and Company, whose main building houses the Rhinebeck Department Store today, set up this annex on Montgomery Street just north of the main intersection to cater to the rapidly growing popularity of bicycling as a form of both leisure and transportation. Later, this would become Sam Fichera's Shoe business; today, it is a retail store. (Photograph by F. DuFlan; MRH.)

The extension of the New York Central Railroad north to Rhinecliff (it reached Slate Dock on October 1, 1851) was the single largest factor contributing to development of both Rhinecliff and the larger town of Rhinebeck. The station seen here at the foot of Shatzell Avenue, just below the Rhinecliff Hotel, served until the current station replaced it. It was built in stages between 1912 and 1914. (Brewster Collection, RHS.)

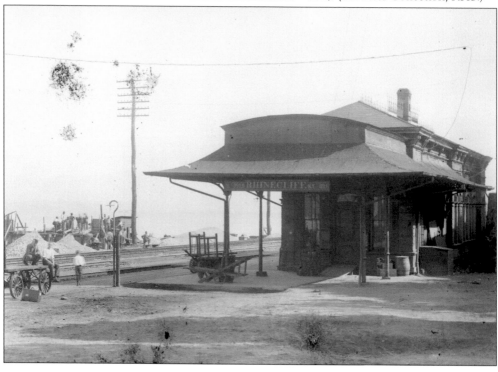

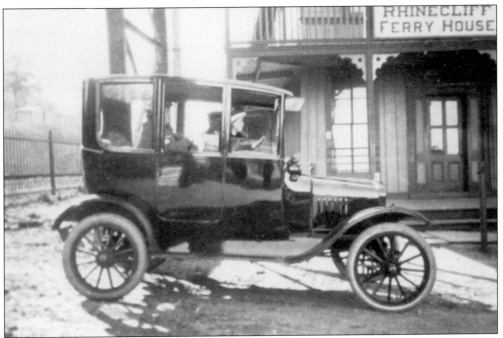

The Rhinecliff Ferry House stood on the west side of the New York Central tracks. This scene from the 1930s was a frequent one while passengers waited, sometimes not as patiently as these auto occupants, for the next ferry to arrive and unload completely before they could get on. The building has been torn down. (MRH.)

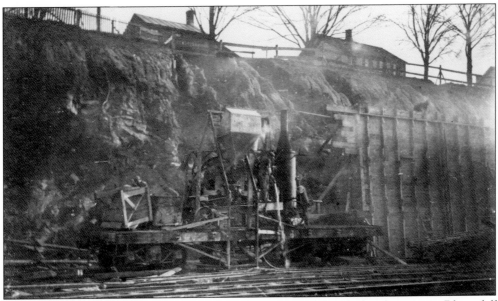

New York Central's decision to construct a new and much larger railroad station in Rhinecliff and to add more tracks between New York and Albany required blasting away some of the cliff where Dutchess Terrace had been and building forms to hold the concrete for a retaining wall. It was a massive undertaking, as seen here at an early stage in 1912. (MRH.)

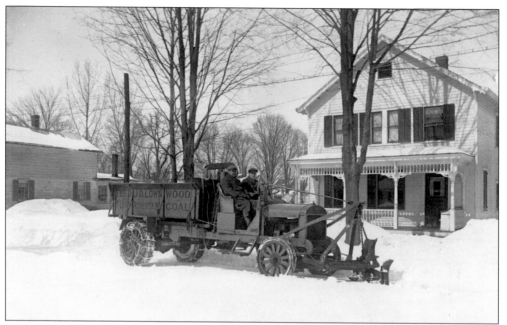

By 1923, coal delivery had become more sophisticated. The men in the truck are Harry Murck on the left steering the plow and Wallace Lown, who is steering the truck. Today's trucks use snow or radial tires, but those were not available in the 1920s, and anyone driving in snow knew that one needed chains to avoid getting stuck. (Photograph by Ed Tibbals, MRH.)

George Bravender, at center in bow tie and overalls, owns this automobile repair shop. The individual seated at left with his hands over his ears is most likely the customer for whom he is repairing this tire. The noise was deafening, made in such shops by the steel bars pounded by steel mallets against steel tire rims to pry tires loose. (MRH.)

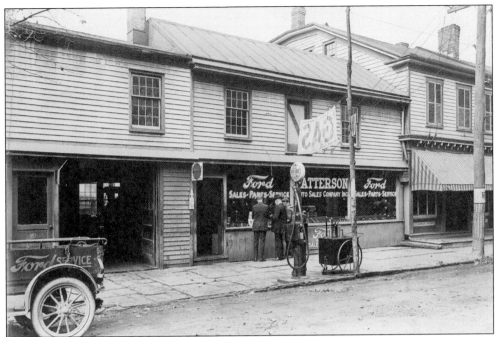

Around 1919, Robert Patterson's Ford Garage was located on Montgomery Street between "white corner" (today a parking lot) and the building that is now Foster's Restaurant. Patterson sold cars, serviced them, and pumped "That Good Gulf Gasoline." The use of cars and trucks to replace horse-drawn vehicles was finally taking off, largely because of Ford's introduction of the mass-produced and affordable Model T. (MRH.)

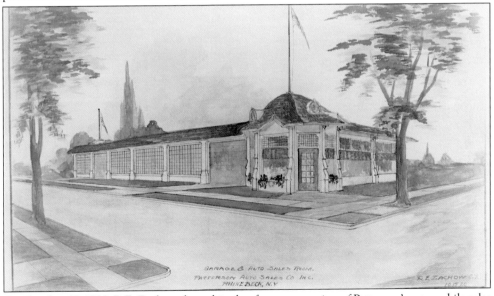

On October 15, 1920, R.E. Zachow drew this plan for an expansion of Patterson's automobile sales and service business. The building today, at the corner of Livingston and Montgomery Streets, appears largely as it did in this design. Patterson sold it by 1927 to the Hartshorn family, who operated an automobile dealership here for over 70 years. They have more recently converted the building to a restaurant and retail shops. (MRH.)

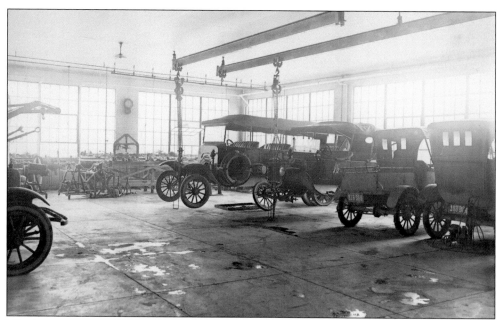

The large amount of light entering this garage may overexpose photographs, but it creates a very good working space for mechanics servicing the two large vehicles hoisted at center. Patterson had moved into this location when this photograph was taken around 1922. Within a few years, the Hartshorn family would acquire it from him. Today, it is a restaurant and retail businesses. (MRH.)

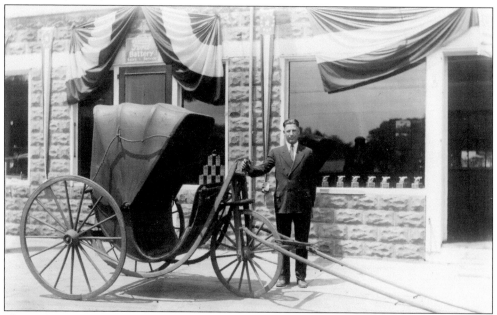

Shown here, Leonard Tremper just opened T and T Ford with his brother Stanton and their father, Pascal, at West Market and Garden Streets in the 1920s. They were preceded here by the Haas Auto Agency, before that by a lawyer's office, the Fraleigh Livery Stable, and even earlier by a home belonging to one of the Livingstons. The three-wheeled chaise once belonged to Mary Garrettson. (MRH.)

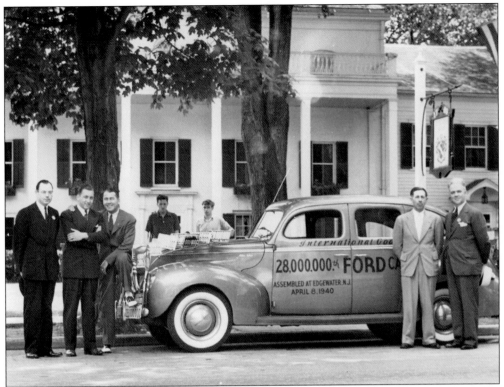

The many license plates on the hood of this car attest to the travel accomplishments of this recently minted Ford, on display before the Beekman Arms in 1940. At the far left is Tracy Dows, most likely in his role as owner of the hotel, and second from right is Stanton Tremper, owner of T and T Ford. (MRH.)

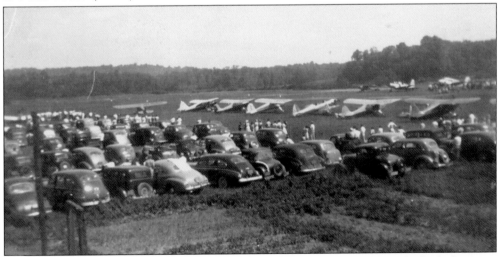

Cozine Field, next to where Chancellor Livingston Elementary would later be built, began as an emergency-landing stop for postal flights between New York and Albany. The landowners were brothers Ray and Art Cozine, both in the movie business. The airstrip became the site of numerous air shows and precursor to the Rhinebeck Aerodrome. On July 4, 1946, this Rhinebeck Airways meet was well attended by both flyers and spectators. (MRH.)

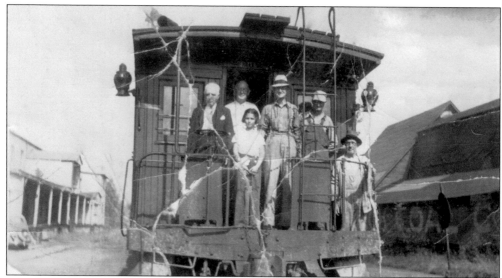

Stationmaster John Quineen is on the left on the last train leaving Rhinebeck's Hog Bridge Station in 1938. The child is Nancy Lown. Called the "Hucklebush" (it moved so slowly one could allegedly pick berries from passing bushes), the Rhinebeck & Connecticut Railroad had undergone numerous reorganizations trying to survive. On the left is the Whitfield Rhynders place; on the right is the Rhinebeck Coal Company. (Photograph by George E. Lown; the Schaad family.)

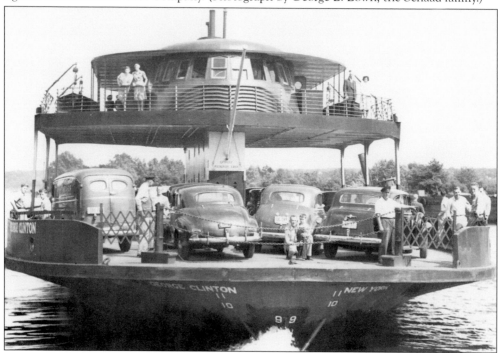

Pictured here around 1950, the *George Clinton* is leaving Kingston on its way to Rhinecliff. After sporadic service during the war, the Rhinebeck and Kingston Ferry Company dissolved in 1944, upsetting both sides of the river. It took another two years to resume service, this time under the State Bridge Authority, which lasted only until late 1956. In early 1957, the Kingston–Rhinecliff bridge was ready to open, completing a 250-year run for ferry service. (MRH.)

Six

HOME FRONT

Rhinebeck's sense of commitment to the nation very likely began with its citizens, such as Gen. Richard Montgomery, who volunteered at the request of General Washington and was killed attacking Quebec, and Robert R. Livingston, who drafted the Declaration of Independence. Families and others who remained at home in Rhinebeck found various ways to exhibit their patriotism and support their soldiers.

During the Civil War and World Wars I and II, letters from the troops, for example, were often shared by the families with the local newspapers and published for all to see. It was understood that during war, sacrifice at home would be expected and accepted. There was rationing. Children joined their parents in collecting scrap metal. Money needed to be raised to support the war effort, and in the four Liberty Bond drives, Rhinebeck raised twice the national average. During World War I, men exempt from the draft participated as members of the Home Defense Corps, training at the Dutchess County Fairgrounds and ready to leave their homes or jobs at a moment's notice. During World War II, Rhinebeck artist Dorothy Knapp designed numerous patriotic postal cachets for the US Postal Service while teaching art at Rhinebeck High School. She was a very modest person, and many of her students never knew of her work until they read about it in the newspaper.

Called Decoration Day when this photograph was taken around 1895, this child is waiting for the Memorial Day parade. She seems to be having no fun at all. She is dressed formally and is also wearing an unusual hat. (RHS.)

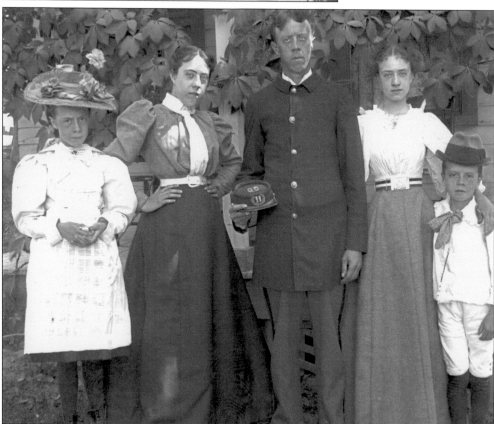

New York State sent more soldiers to the Civil War than any other state. The hat he is holding in this c. 1900 scene with his family confirms him as a veteran of the 22nd New York Volunteer Infantry Regiment. Visible from Route 9, the statue of the Civil War soldier in the Rhinebeck cemetery reminds passersby of those who served from Rhinebeck. (RHS.)

Calvin Rikert enlisted early in the Civil War as a member of the 128th New York Volunteer Infantry Regiment, and he served throughout the war. After the war, he worked as a stonecutter for Wiliam Kent's marble works in Kingston. He also worked on the State Capitol during its construction. He and his brother Elmore later bought Jacob Schaad's livery and stagecoach line business. (MRH.)

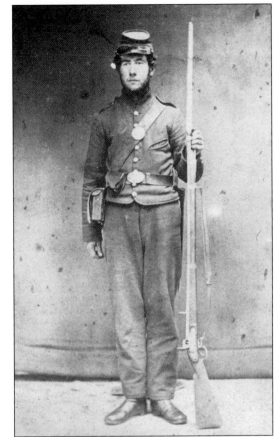

Sam Fichera's shoe store and the fireworks store next door serve as the backdrop for these individuals waiting for a parade in 1919 on the east side of Montgomery Street, just north of the four corners. Individual business owners have draped all manner of bunting and flags above and in front of their shops to emphasize their patriotism. (MRH.)

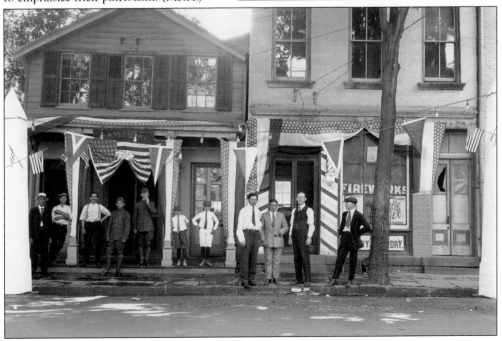

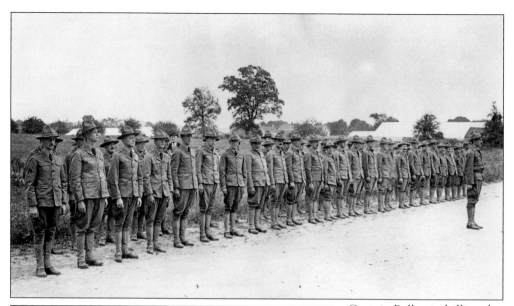

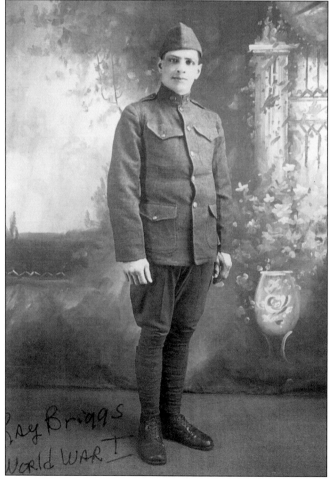

Captain Pullen is drilling the Home Defense Corps during World War I. The men were mustered into this local form of service soon after the US Congress declared war on Germany April 6, 1917. They held regular practices at the fairgrounds. While the members of the Home Defense Corps were not active members of the military, it was a way to be involved without abandoning one's job or family. (MRH.)

Rhinebeck resident Cpl. Raymond L. Briggs enlisted on October 8, 1917. A musician with the regimental band, he found himself in the Argonne offensive serving as a stretcher-bearer. He left a diary that provides a detailed daily account of the war as a part of his legacy. (Alan Coon.)

William Eckert appears young, but at 22, he is older than many other World War I recruits. Born in Rhinebeck in 1895, he had been working as a farmer when he enlisted in 1917. Although it was late in the war, there was still plenty of action by the time he arrived in Europe. He served in the Baccarat Sector, in the Oise-Aisne offensive, and in the Meuse-Argonne offensive. (MRH.)

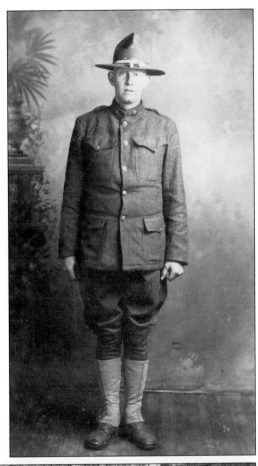

A sticker on the side of the speaker's coach reads, "Halt the Huns." In April 1918, the occasion drawing such a large crowd is the third of what would be four Liberty Loan Drives. Subscribing to the bonds became a symbol of patriotic duty. By selling such bonds, the government raised $17 billion, an average of $170 per person. Rhinebeck alone raised $1,345,471, or $380 per person. (MRH.)

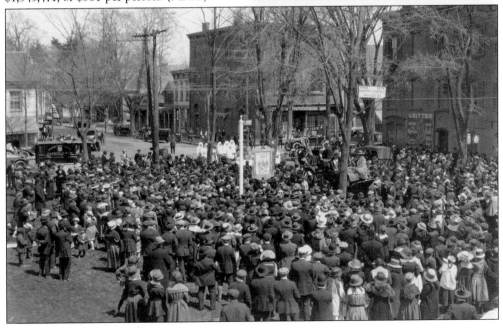

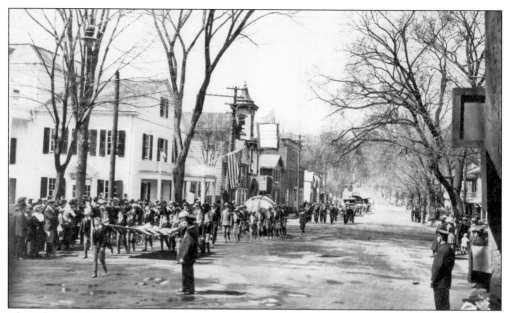

The Liberty Ball, an enormous balloon, is being rolled from Rhinecliff through Rhinebeck to Hyde Park in April 1918 by the local Boy Scouts as part of a national effort to generate interest in buying bonds that would help pay off the debt the US government was incurring fighting World War I. This was the third of four Liberty Loan Drives. (MRH.)

The Rhinebeck Hotel has just been remodeled and renamed the Beekman Arms. In the foreground, Allen McMullen, in May 1918, is going from Albany to New York City to encourage donations to the Red Cross War Fund. (Kay Verrilli, MRH.)

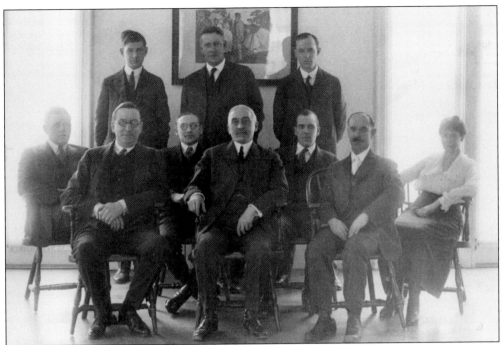

These prominent local residents made up the Rhinebeck War Board during World War I. They include, from left to right, (first row) Tracy Dows and two unidentified; (second row) Sumner Simmons, Joseph Griffing, Benson Frost, and secretary Jessie Snyder; (third row) Dr. Howard Bulkeley, Benjamin Tremper, and ? O'Connell. (MRH.)

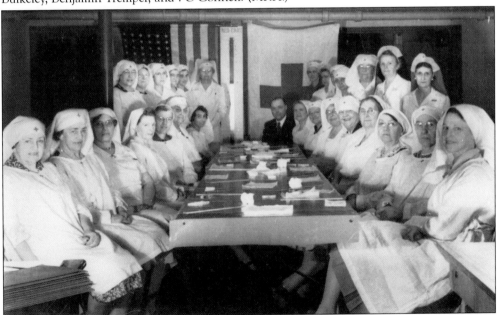

Red Cross nurses meet at the home of Anna Hill in April 1943. During World War II, the US War Department asked the American Red Cross to recruit nurses to serve in the Army Nurse Corps. Red Cross volunteer committees, such as this one, were established in every state and met the needs identified by the military. (Photograph by Frank Asher; MRH.)

Homes Now Under War Rules

Yesterday will be remembered as the day when the war touched the homes of rich and poor alike, with various rationing and conservation orders becoming effective. Among the home-front economies were:

HEAT—Fuel-oil rationing began in thirty Eastern and Mid-Western states and the District of Columbia under a plan designed to provide the minimum needs of homes and industries. Registration for ration cards will take place soon, probably after Oct. 15.

MEAT—Consumers began voluntary rationing, with a maximum of two and one-half pounds a person a week, as the Office of Price Administration ordered meat packers to cut by 20 per cent the amount of meat for civilian consumption. Coupon rationing is expected by early next year.

SPEED—A thirty-five-mile-an-hour speed limit was imposed on every street and highway in the nation, the first in history. Designed to conserve rubber and gasoline, the programs call for $25 fines or five days' imprisonment or both for violators. In New York State summons are being issued to violators.

TIRES—Owners of used tires and tubes with few exceptions were forbidden to sell or transfer them pending establishment of a ration program. New and recapped tires and tubes are now being rationed.

MILK PRODUCTS—New York distributors were considering a plan to educate consumers to use medium rather than heavy cream to increase the amount of butter fat available for the armed forces and our allies.

FOOTWEAR—Unless a man can qualify under four employment categories when he applies at his local ration board, beginning Monday, he will be unable to buy any of six types of men's rubber boots and rubber work shoes. Unserviceable rubber footwear must be turned in as salvage.

As announced in the *Rhinebeck Gazette*, these war rules were accepted as necessary to win the war with minor variations in every other newspaper in the nation. They did require a change in habits, however. The 35 mile-per-hour speed limit was especially challenging, with violators subject to fines and imprisonment. This sacrifice, along with many others, allowed the country to save sufficient fuel to win the war. (MRH.)

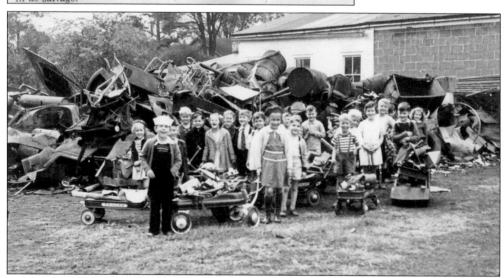

Recycling had a different motivation during World War II. At the time of this photograph, in October 1942, scrap iron was needed by military-related industries, and families were sensitive to the need to set aside any scrap metal. In school, children were also asked to consider using any allowance they might receive to buy war stamps, and awards were given to schools selling the most. (Photograph by Frank Asher; MRH.)

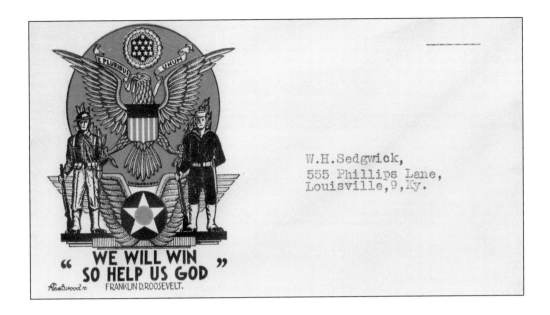

The creator of these designs on first-day postal covers was Rhinebeck High School art teacher Dorothy Knapp. An art form referred to in the stamp world as "cachets," they are stamped designs, rather than a cancellation or preprinted postage, to commemorate some event. Many of her students never knew that her work was being mailed as first-day covers from post offices all over the country. "We Will Win so Help us God" and "Air Power: Avenger in War, Trail-Blazer in Peace" were two of many cachets she designed as part of the home-front effort. The Museum of Rhinebeck History recently exhibited many of her works. (MRH.)

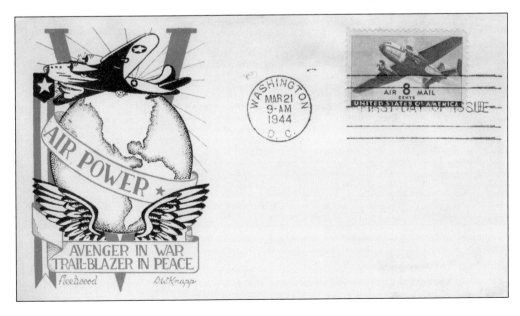

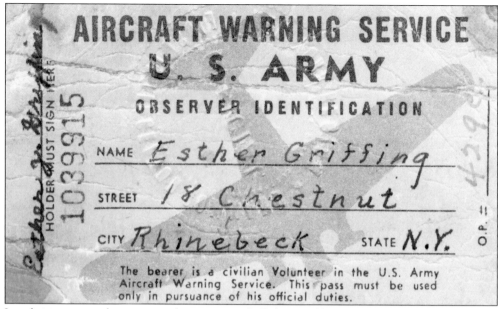

Local citizens served as spotters of enemy aircraft. Esther Griffing was assigned to an observation post on Rowland Sharpe's farm, near the current location of the Rhinebeck Performing Arts Center. After Pearl Harbor, many feared enemy planes coming here, especially because of Rhinebeck's closeness to the president's home in Hyde Park. Military personnel manned an earlier version of the current tower at Ferncliff Forest for the same reason. (Esther Griffing, MRH.)

Veterans' organizations played an important role on the home front. Here, the members of Veterans of Foreign Wars Fitzpatrick–Chapman Post 9255 celebrate Ed White's 98th birthday. White is fifth from left in the first row. Rhinebeck had worried that no one would see him again after he was taken prisoner during combat in Europe in World War II. He survived to become the post's most senior veteran. (Photograph by Pat Coon; MRH.)

Seven

PUBLIC SERVICE

The development of the local school system began with one-room schoolhouses. By the late 19th century, most of the schools within the town of Rhinebeck consisted of a potbellied stove; a blackboard; sufficient desks for all of the students, whose ages could range from 6 to 16; some textbooks; one large room; and a teacher expected to instruct the curriculum appropriate to each child. District 5 in the village and District 2 in Rhinecliff had larger buildings and more teachers. The distribution into a dozen districts remained in place until the 1939 fire. A discussion about centralization then began that was not resolved until the central school opened in 1952. Today, after additional expansion, that building serves both high school and middle school students.

After losing many structures in the commercial heart of the village in 1864, Rhinebeck understood (better than ever) the need for firefighters who could respond quickly to a fire. Men with strength and stamina were needed to operate the pumps that sucked water from a source and delivered it with sufficient force to kill the flames. Loss due to fire remained common, particularly on farms and areas more remote from the Fireman's Hall, but even structures close to the center of the village, such as the Methodist and Third Lutheran Churches, continued to suffer major fire losses.

As the village and town grew, the demand increased for better roads, police, a local system of justice, and supervisors and clerks. In 1930, to address the physical health of the community, the Northern Dutchess Health Center opened, training nurses, delivering babies, and treating the sick, succeeding Thompson House in providing health care to the community.

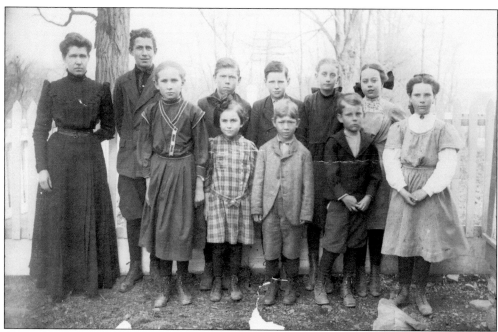

Around 1910, the Wurtemburg School was just north of the Wurtemburg Lutheran Church and adjacent to the cemetery. Teacher Mamie White's students are, from left to right, (first row) Olive Ayres, Kathleen Traver, Aaron Wager, George Green, and Ruth Green; (second row) Ralph Marquet, Arthur Wager, Leland White, Florence Closs, and Leona Traver. The building has moved to Route 9G and is now a private home. (MRH.)

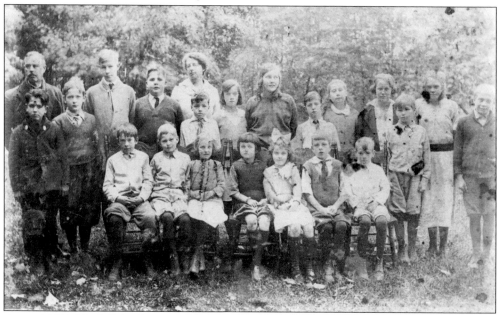

Around 1914, Hook School was on River Road near Hook Road. River Road was so narrow that students used the tops of the stone walls as their sidewalk. Teachers Lewis and Elizabeth Barber are in the back row. The chairs may have been moved to the schoolyard in the interest of better lighting, since the school is heavily shaded. Today, the building is a private residence. (MRH.)

In 1910, Cornelia Demarest began teaching at the age of 21. She taught mostly at the Eighmyville School on Salisbury Turnpike. Written by her granddaughter, a narrative in the museum's archives of Demarest's career as a teacher in a one-room school is a moving account of the challenges faced by an educator in such a setting. Demarest retired from teaching in the 1950s. (Frank Gaglio, MRH.)

Shown here is the Flat Rock School in Heermanceville on the north side of Rhinecliff Road in 1939 or 1940. The teacher beams with pride for her students dressed up for their annual portrait. From left to right are Max Mielich, Mildred Stahl, Nancy Traver, Jim Ironsides, Harold Lippincourt, Art Lacke, teacher Fannie Knickerbocker, Jack Ironsides, and Bob Fitzpatrick. Note the dog has been included in the photograph. Today, the building is a private home. (MRH.)

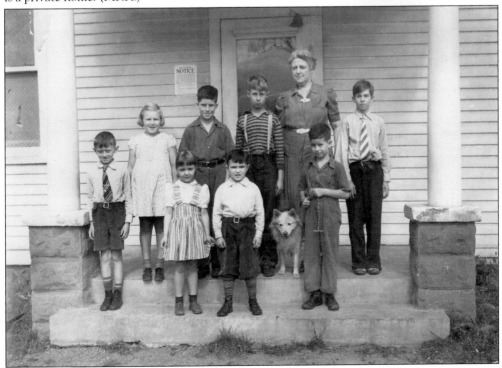

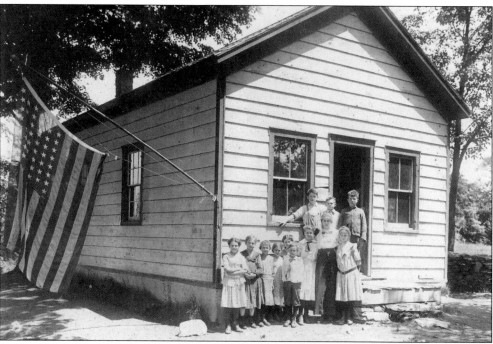

JOHN McD. CROFTS
LINLITHGO, N. Y.

June 12, 1929

Mrs. Frances Knickerbocker
Canaan, N.Y.

My dear Mrs. Knickerbocker,

Your letter of June 10th received. Sorry to have missed you on Sunday. There is just one point which I neglected to speak of in my letter to you and that is this that Dist. 2 has always been taught by a Protestant and I feel certain the board of trustees would not be willing to make a change at this time. Since writing to you have understood that you are of the Catholic faith, if this be true, it would be better for all concerned if we let the matter drop. Please understand that there is no reflection on the Catholic faith implied for you have a perfect right to your faith, if a Catholic, as I have to mine as a Protestant.

Of this I am certain that you bear a fine reputation as a teacher and all other respects and do hope you are of the Protestant faith, if not please consider the matter as closed.

Yours very truly,
John McD. Crofts

Religious discrimination was alive and quite willing to go on the record in 1929. Here, a 1929 letter of rejection from a school in Linlithgo, New York, is addressed to Fannie Knickerbocker on the basis of her Catholic faith. The Rhinebeck School District was not as discriminatory and hired her to teach at the Flat Rock School. Ackert Hook School is pictured below around 1900, where Ackert Hook and Primrose Hill Roads meet. From left to right students are (first row) Carl Beach; (second row) Pearl Justus, Rose Kesshouer, Gwendolyn Kipp, Gladys Stokes, Grace Kipp, Helen Beach, teacher Verna Traver, and Eunice Stokes; (third row) Sterling Kipp, Henry Phillips, and Henry Justus. (Both, MRH.)

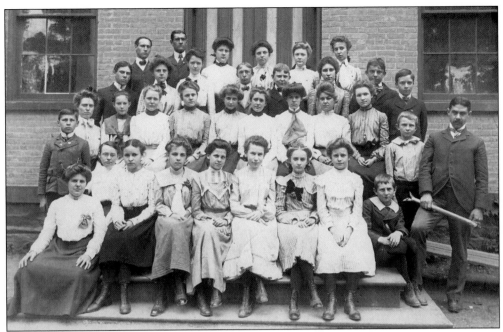

In this June 1902 photograph, men display a very stern demeanor at Rhinebeck High School. The head teacher appears on the right. (Photograph by Theo deLaporte; MRH.)

On June 18, 1837, the Sunday school receiving book of the Stone Church School shows the occupation of each parent. With one exception, a brewer, the parents are farmers ("do" means "ditto"). The age of the 16 students ranges from 7 to 16. Many are siblings. A similar register would have been maintained for school during the week, most likely with largely the same names. In the one-room school, this wide an age range was typical. (MRH.)

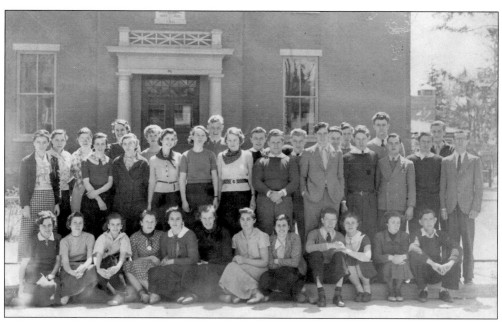

The Rhinebeck High School class poses in front of their school in the late 1930s before fire would destroy the building. It was initially built in 1844, with additions in 1869, 1901, and 1911. In 1952, higher grades moved to the new central school building, while the remodeled older structures housed the lower grades. Today, it is the Brogan Center. (Photograph by Stanley; MRH.)

The Rhinebeck Country School established a residential treatment facility on the site of the former Tracy Dows estate and operated a group home on South Street across from the Reformed Church. For 40 years, the school served developmentally disabled children. The program closed in the 1980s. After considerable local controversy, the campus reopened as a drug-treatment facility. (MRH.)

Here, Henne Free is graduating from the DeGarmo Institute in 1880. Prof. James DeGarmo bought the former Rhinebeck Academy, which had operated since 1840 on the Methodist Church grounds, then on Livingston Street west of the Third Lutheran Church. He added to it in 1871 to accommodate more out-of-town students, then moved the school to Fishkill in 1890. Numerous local teachers, lawyers, and ministers were DeGarmo graduates. (Photograph by John Coumbe; MRH.)

After the April 1939 fire, Rhinebeck School No. 5 was able to serve only high school students, barely visible in the right rear of the photograph. The building had previously housed kindergarten through 12th grades. The lower grades had to be farmed out to a variety of local buildings. By 1952, after centralization had been agreed to and a new school construction, students had been housed in 16 different buildings. (MRH.)

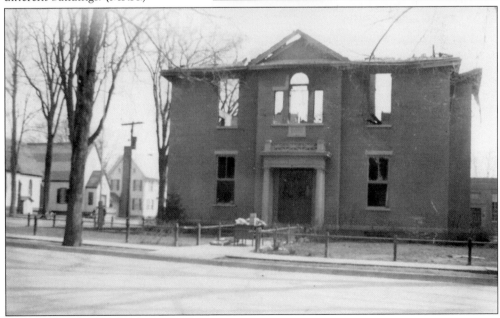

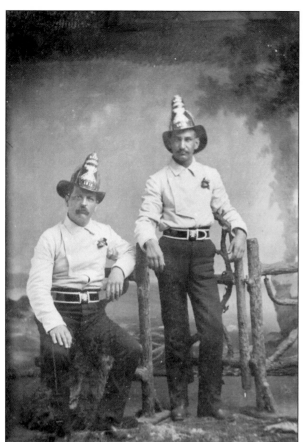

Two Rhinebeck firemen appear in their ceremonial outfits around 1875. The 1864 fire that destroyed many buildings on the south side of East Market Street was still fresh in everyone's mind. Although the risk of fire was lessened by the replacement of older wooden buildings with brick structures, firemen were increasingly viewed as very important public servants. (MRH.)

Immaculately maintained, the pumper Pocahontas dates to a time when arm strength and stamina determined the distance a hose could shoot water. "Pokie" was a mainstay of the Rhinebeck Fire Department for many years and remains a source of pride for local firemen. Until a few years ago, it was still traveling occasionally to compete at firemen's musters throughout the Northeast. (Photograph by George Burger; MRH.)

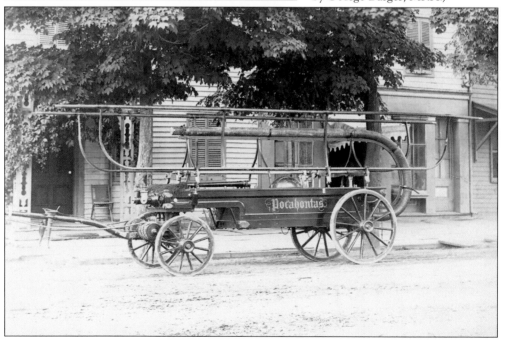

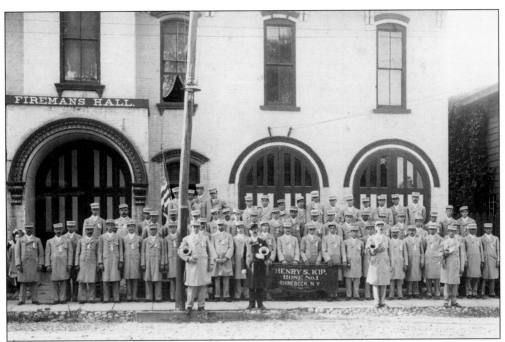

Around 1906, the Henry S. Kip Hose Company, shown above, operated out of this brick building next to the Rhinebeck Hotel on the south side of West Market Street. Out of the 60 men, four carried the voice trumpet, frequently referred to among firemen of the time as a bugle. During a fire, it was used to shout orders to the firemen. Because only the chief and a few lieutenants carried it, the bugle became a symbol of rank. Fireman's Hall was also a popular social center, where the fire department hosted occasional fairs, balls, and other entertainments. Lt. William Sleight, shown at right, was not only an officer in the fire department, but also served the public as Master of Work at the Knights of Pythias, an organization founded on the principles of friendship, charity, and benevolence. (Above, MRH; right, RHS.)

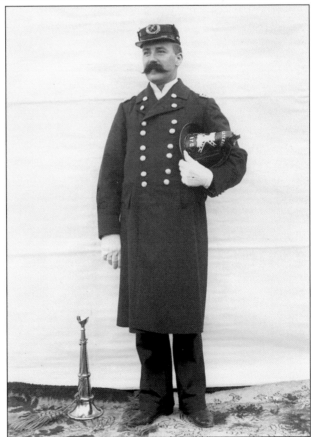

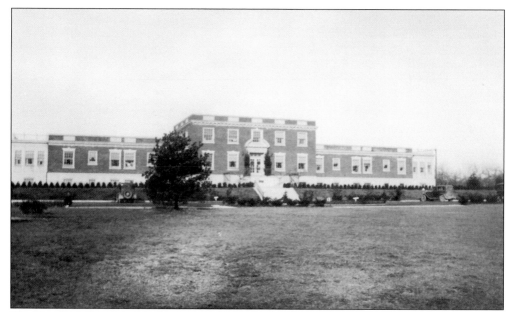

The Northern Dutchess Health Center opened in June 1930. Here, the recently donated hedges run the length of the building in 1939. There were two solariums in lighter-colored brick flanking either end of the building. The hospital has expanded considerably but has managed to keep most of the large expanse of lawn between the hospital and Route 9. (MRH.)

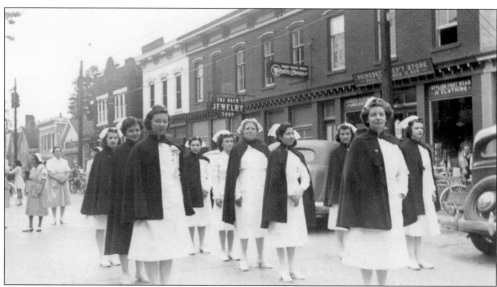

Nurses led by Bea Cozine (right, looking at camera) appear in a village parade around 1940. There was a Northern Dutchess Training School for practical nurses in Rhinebeck until the late 1930s. Students lived on the third floor of the hospital, while director Beatrice Tremper Cozine lived on the second. She later became first hospital administrator, a position she held for 40 years until 1967. (MRH.)

New Assistants At Northern Dutchess Health Center

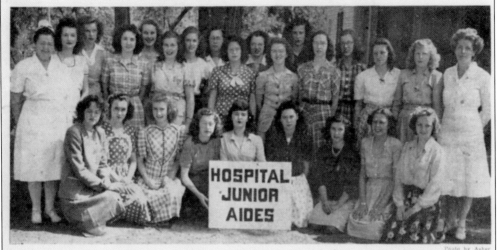

Organized and trained by Miss Emilie M. Schultz, school district nurse, the Junior Nurses' Aides pictured above are prompt and efficient workers at the Northern Dutchess Health Center, according to Mrs. W. Ray Cozine, superintendent.

The entire membership is shown here. They are: front row, left to right, Betty Depew, Frances Baxter, Alice Lare, Doris Funk, Helen Welch, Esther Griffing, Nancy Lown, Olga Depew and Joan Marshall; standing, left to right, Miss Schultz, Muriel Pulver, Virginia Dittmar, Ann Sullivan, Marjorie Walberg, Grace Pottenburgh, Marjorie Odell, Judy Bulkeley, Nancy King, Audrey Hester, Margaret Haskins, Betty Lane, Grace Scism, Louise Hill, Catherine Kiniry, Bernice Olson and Mrs. Cozine.

A partnership between the school district and the hospital gave students an opportunity for hands-on learning about this potential vocation. Students also gave the hospital some much-needed help at a time when nurses were still in short supply due to the war. (*Rhinebeck Gazette* photograph by Frank Asher; MRH.)

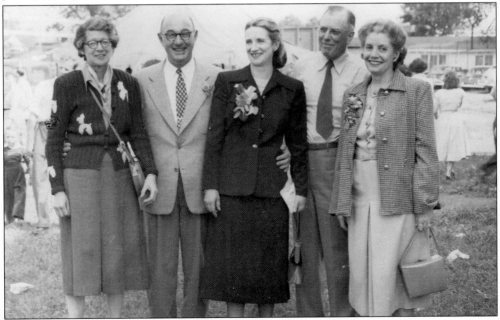

On Memorial Day in 1950, board members of the Northern Dutchess Health Center enjoy the hospital fair. From left to right are Marion Yager, treasurer Paul Rosenthal, Mabel Silvernail, Pres. Benson Frost, and hospital administrator Beatrice Cozine. (Photograph by Frank Asher; MRH.)

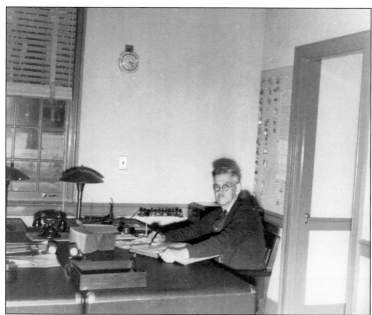

In February 1940, Rhinebeck's town clerk, Joseph C. Lawrence, appears in his new office. The keys are all in place, and everything else is likely very well organized. The former town hall had been torn down to make way for the new post office, so it was necessary to build this new town hall. The building still serves as town hall. (Photograph by Frank Asher; MRH.)

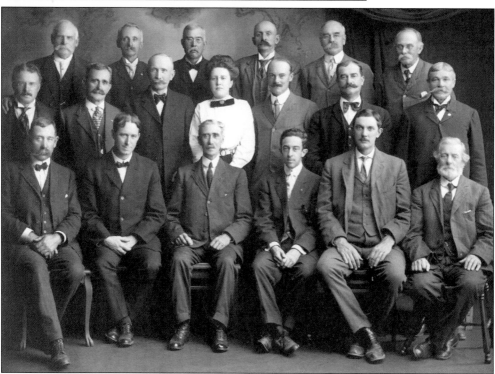

Mandeville Frost is the third from left in the first row. He was elected Rhinebeck town supervisor from 1904 to 1905 and from 1907 to 1908 and represented Rhinebeck in the Dutchess County legislature. Here, he is with his fellow members of the county board of supervisors. Members of the Frost family were Democrats in a town that was consistently Republican. Mandeville's son Benson became a prominent attorney and close friend of President Roosevelt. (Photograph by the Gallup Studio; MRH.)

Eight

GREAT ESTATES

The children of Margaret Beekman and Robert Livingston would share in the most significant subdivision in the history of northwestern Dutchess County, their properties becoming the sites of many great estates.

Margaret and Robert's daughter Janet Livingston built Grasmere. She lived there only a few years, leaving it to other Livingstons, including Joanna, Peter R., and later James Livingston. In the 20th century, it was home to Ernest and Maunsell Crosby, the latter best known for his contributions to ornithology. Daughter Catherine Livingston married Methodist minister Freeborn Garrettson, despite her mother's misgivings. They received land east of the village they later traded for Wildercliff. Grandfather's namesake, Henry Beekman Livingston, received the Kip–Beekman–Heermance house, despite his irresponsible behavior toward women. President Roosevelt admired its history and used it as a model for Rhinebeck's post office.

Ellerslie, best known for the tenancy of Anna L. and Levi P. Morton, traces its origins to an 1814 structure built by a Livingston granddaughter. The origin of Rokeby, Orlot, Marienruh, and Ferncliff can be traced to the marriage of Margaret and Robert's daughter Alida to John Armstrong and the subsequent union of their daughter Margaret Armstrong to William B. Astor. Linwood was built in 1779 to house Margaret Beekman's namesake daughter and son-in-law Dr. Thomas Tillotson.

The estates boasted magnificent views and impressive gardens, and most also operated as farms. They depended on large staffs that lived in the community and whose income boosted the local economy. While many estate owners worked elsewhere, they cared about the churches, the schools, the roads, and the less fortunate, and Rhinebeck benefited from their concern.

James B. Livingston drives his four-in-hand at his home Grasmere in 1886. Unlike his forbears who would have been riding in the coach, this owner prefers handling the horses from the front seat with his golf clubs hanging from the rear. The coach is parked at the mansion's east portico; the front steps to the mansion are behind the person holding the first pair of horses. (The Mensch family.)

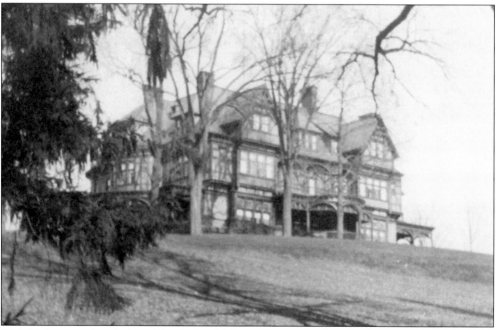

This Tudor mansion designed by Richard Morris Hunt served as the home of Vice Pres. Levi P. Morton from the 1880s until his death in 1921. This view is from the west. The site once belonged to Maturin Livingston, who christened it Ellerslie. The mansion became classrooms and a dormitory for Cardinal Farley Military Academy in 1946, only to be destroyed by fire in 1949. The military school continued on the property until 1971. (MRH.)

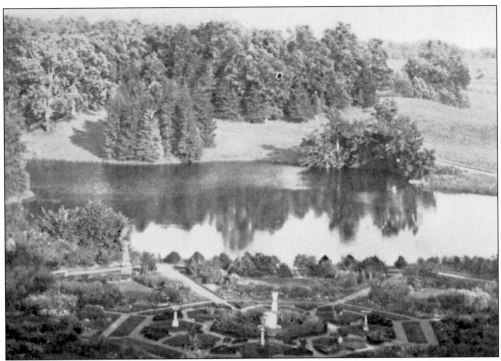

Shown above in the 1910s, the Italian garden at Morton's Ellerslie Mansion required 14 gardeners to maintain it. This view is from the rear of the mansion (the front faced the Hudson) down toward the lake. In a 1912 map, shown below, pipes separately pump water from the lake, the Hudson, wells, and collected rainwater since certain plants (and animals, of which he raised many) did better with one or the other. The garden and lake are in the lower left of the map, the mansion at center, and the water tower at upper right. The dam that previously held back the lake water has collapsed, and the garden has returned to nature. (Above, RHS; below, Teal Map Collection, RHS.)

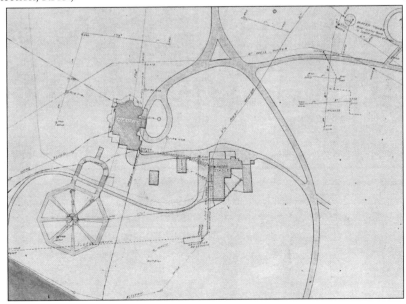

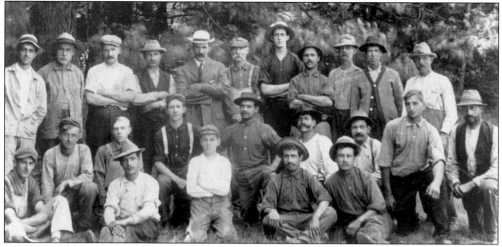

Maintaining an estate required considerable manpower. This group was a small portion of the Ellerslie workforce. There were gardens to keep up, cattle to feed, fences to repair, buildings to maintain, and a mansion to keep in sparkling condition. Pictured here, the older workers most likely had worked for William Kelly before Levi Morton bought the property from him in the 1880s. (American Legion, MRH.)

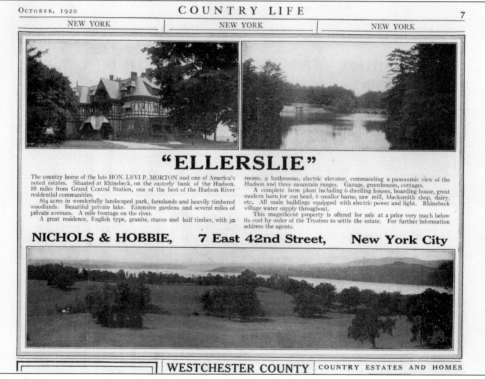

Levi P. Morton passed away in May 1920, and his family decided to put the estate on the market. Despite this attractive advertisement, it was never sold. Daughter Helen Morton would live quietly on the property for another 30 years, donating it to the Catholic Church in 1946. Cardinal Farley Military Academy occupied the site until 1971, then Pius XII Youth and Family Services until 2001. (MRH.)

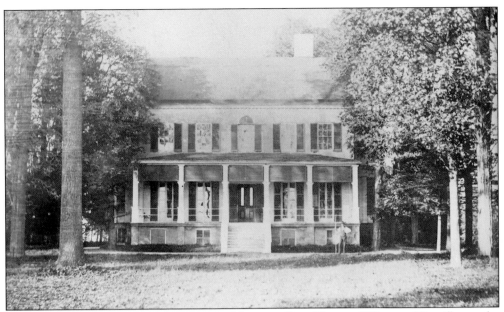

Built in 1780, Linwood was the residence of Surgeon Gen. Thomas Tillotson. His wife was the great-granddaughter of the original patentee, Henry Beekman. At a time when stone or wood were the only available construction materials, Tillotson imported brick from England to build this house. It would be torn down in 1883 to make room for the residence of beer magnate and Yankee owner Jacob Ruppert Jr. (Ruppert Collection, RHS.)

Around 1890, everything is in perfect order at the entrance to John Pawling's place just south of the border with Hyde Park, named after an officer who had served in the Revolutionary War. The property was part of a 1696 royal patent to one of Pawling's ancestors. For decades, the estate was known nationally as the site of the Pawling Health Manor, run by health guru Joy Gross. Now it is Belvedere. (MRH.)

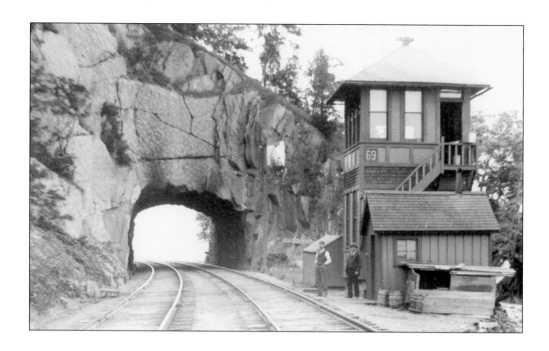

The above photograph from 1896 shows the earlier New York Central tunnel, viewed from the north, passing through the Astor estate where that property meets the Hudson River. Higher train speeds, taller loads, and increased concern with safety in the 1910s required that the earlier tunnel be abandoned and replaced by a taller and wider tunnel, seen in its final stage of construction at right below in a view from the south. The enormity of the project can best be appreciated by noticing the tiny size of the men standing above the completed concrete work at right. (Both, Winthrop Aldrich, MRH.)

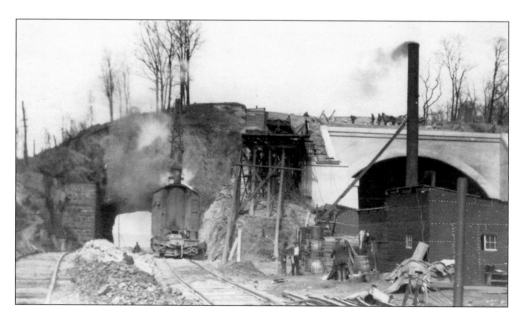

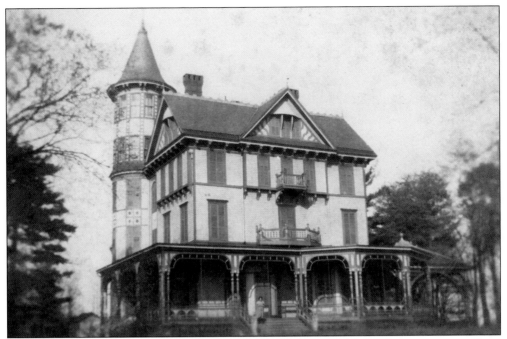

Wilderstein appeared with the shutters closed in 1905 because the family was on a years-long sojourn in Europe. Built by Thomas Suckley in 1852, it was substantially enlarged by his son Robert in 1888. Robert's daughter Daisy enjoyed having neighbors for tea on the veranda. She had no heirs and donated Wilderstein to an organization that has made it the most accessible of Rhinebeck's great estates. (Wilderstein Preservation.)

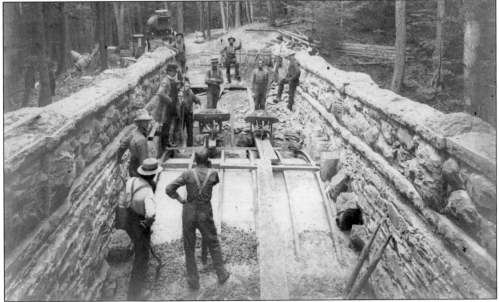

Shown here in 1900, the men behind the wheelbarrows appear to be waiting for the signal from the man in the bowler hat to pour fresh concrete on to the steel arch of this stone bridge. Located on the farm road on the Astor estate and connecting the teahouse with the dairy complex, this was one of many such roads at Ferncliff. The bridge is still there. (MRH.)

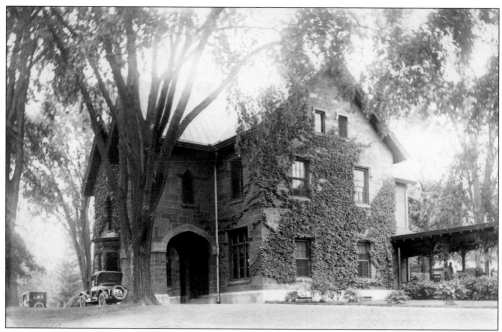

Brothers Charles (later a Civil War general) and William Wainwright built this English Gothic house in 1847, added a dairy cottage in 1849. They called their 350-acre farm the Meadows. Douglas Merritt renamed it Leacote when he bought it in 1875. The mansion was lost in a 1977 fire, but many of the two-dozen Gothic outbuildings constructed between 1847 and 1926 remain, and the property continues as an operating farm. (MRH.)

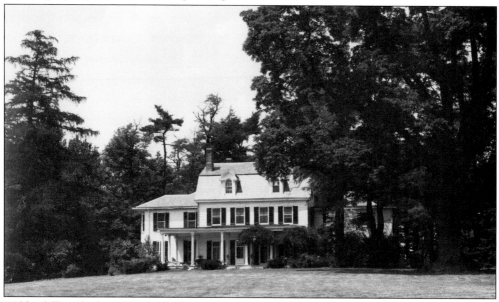

Wildercliff was built in 1799 for Catherine Livingston and the Rev. Freeborn Garrettson, a founder of Methodism. Standing on a bluff just north of Linwood, it is modest in comparison to other great estates overlooking the Hudson River. The wings and south-facing French windows added in 1830 have not changed the original structure's basic Georgian style. (Photograph by Charles Eggert; MRH.)

Alice Olin Dows, in pearls, trailing gown, and unusual hat, poses with Harrie T. Lindeberg, who is dressed just as elegantly in tails and top hat. Lindeberg was hired to design Foxhollow in 1909 by Alice's husband, Tracy Dows. Lindeberg later redesigned the Beekman Arms and the dairy complex at Ferncliff. (Photograph by Underwood & Underwood; MRH.)

The 1903 wedding of Alice Olin to Tracy Dows is celebrated here at Glenburn. Their children included Olin Dows, painter of the murals in the Rhinebeck Post Office, and Deborah Dows, whose Southlands Foundation has preserved her family property as a site for equestrian activity and for premier views of the Hudson River landscape. (MRH.)

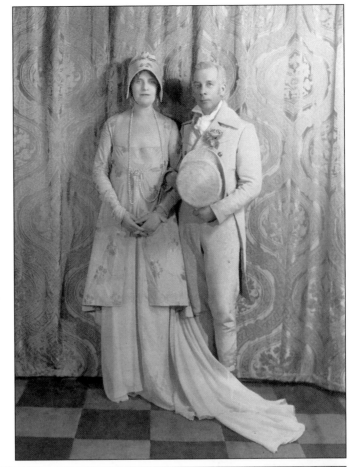

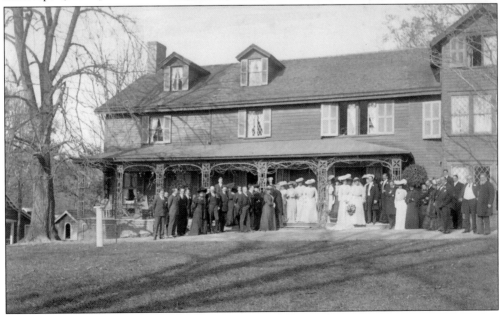

Millionaire entrepreneur Tracy Dows, here at Foxhollow around 1925, came to Rhinebeck after marrying Alice Olin. He was an officer of the Rhinebeck Savings Bank, the Rhinebeck Cemetery Association, and the Red Hook Telephone Company, and financed the expansion of numerous local businesses, including the Beekman Arms and Sipperley Plumbing & Heating. He also worked to preserve the natural beauties of the town and supported bird preservation and protection. (MRH.)

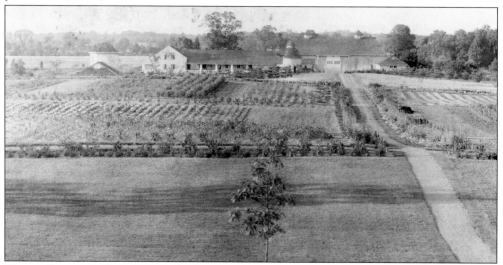

This well-organized garden at Glenburn was typical of the great estates. Fresh flowers were used for decoration, while seasonal fruits or vegetables were used in the kitchen. The low-lying structure on the left may have been a root cellar, dug out of a slight slope to take advantage of the cooler air below ground level to prolong the life of root crops stored there. (Photograph by Harry Coutant; MRH.)

Named after the Native American who transferred this property in the late 1600s to the Kip family, this mansion at Ankony lasted from 1830 until it was razed in 1977. Vincent Astor bought the land in 1930, selling it five years later to Allan Ryan, who founded a purebred cattle operation here. From the 1950s through the 1960s, Ankony Angus were consistent champions. (RHS.)

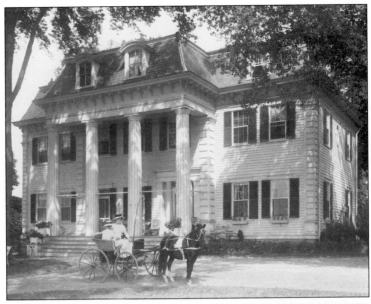

Owner of Linwood and vice president of Ruppert Beer J. Ruppert Schalk stands behind his seated uncle and brewery president Col. George E. Ruppert. The biggest producer of lager beer in the world in the late 1930s, the family also owned the New York Yankees. Pictured here in 1939, a Legion Post is opened in New York City and named in Ruppert's honor. (J. Ruppert Schalk, RHS.)

When his father, John Jacob Astor, went down in the Titanic in 1912, son Vincent inherited his father's fortune, estimated at $200 million. Among his purchases was a yacht he ordered from the Krupp Iron Works in Germany, which they delivered in 1928. He christened it the *Nourmahal*. Shown here in late summer 1933, Vincent welcomes President Roosevelt aboard the yacht. They had known each other since childhood, as both of their families owned estates on the Hudson and both grew up as devotees of sailing. It had not been a surprise when Asst. Secretary of the Navy Roosevelt successfully urged Vincent Astor to join the Navy in World War I. Between the wars, Astor maintained his close relationship with Roosevelt, who made these visits to the *Nourmahal* an annual event. The yacht was later commissioned as a naval vessel in World War II. (MRH.)

Nine

LEISURE TIME

Leisure in Rhinebeck has taken many forms.

Music has always been important to Rhinebeck. The Zenda Mandolin Club and the Rhinebeck Fife Drum and Bugle Corps were two very different expressions of local musical entertainment. Artist Olin Dows and writer Thomas Wolfe pursued their craft here and set a high standard for other artists and writers, many of whom would find Rhinebeck the ideal place for their work.

Picnicking at the edge of the woods, boating on the Hudson River, or enjoying an afternoon on the shore of Crystal Lake have been leisure activities here for many years. For those interested in more vigorous pursuits, the Dutchess County Fairgrounds served as the venue for bike and harness racing in the earlier part of the 20th century and of mini-car racing in the 1940s. There have been many groups engaging in basketball and baseball competitions, even before athletics became tied to the local public high school. Tennis was a favorite of the wealthy living at the great estates and was a favorite of the local citizenry as well.

The interest in flying, shown by those who re-create World War I scenes today at the Rhinebeck Aerodrome, is like that exhibited by an earlier generation of flyers who met at Cozine Field for air meets in the 1930s and 1940s. The public who comes to watch them take off, perform stunts, and land enjoys it almost as much as the flyers.

Pictured here around 1900, the Zenda Mandolin Club was but one of many groups that made music an important part of civic and cultural events in Rhinebeck at that time. The town hall, Fireman's Hall, and the Starr Building often served as the host for popular entertainment events. (RHS.)

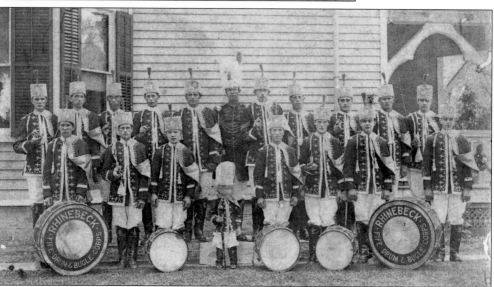

Seen here in 1914, the Rhinebeck Fife Drum and Bugle Corps hosted the state convention of fifers and drummers and themselves took many trophies in their widespread travels. The concept saw a revival when town historian Dewitt Gurnell corralled local youths to learn to play the instruments, don Colonial costumes, and march in the Rhinebeck Fife and Drum Corps in the 1960s and 1970s. (MRH.)

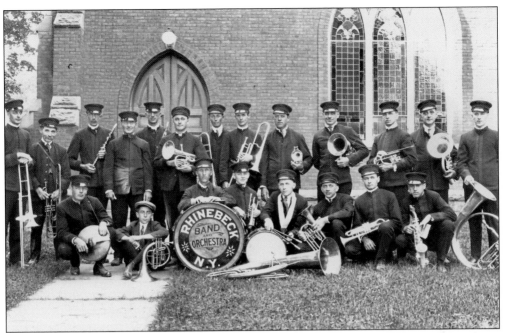

The Rhinebeck Band and Orchestra is posing at the side of the United Methodist Church on East Market Street in 1920. The lively group was in demand at parades and performances, not only in Rhinebeck, but also throughout the region. (Photograph by Shaffer; Gubler Collection, MRH.)

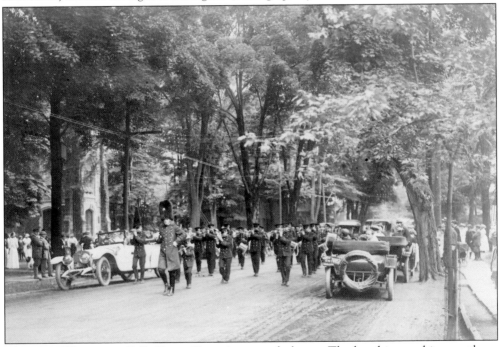

This 1914 Wappingers Falls Drum Corps is a crowd pleaser. The band is marching north on Montgomery Street. The Church of the Messiah is visible on the far side of the street at left. The open-topped cars make an excellent vantage point from which to observe the action. The younger tree at right is staked, possibly to protect it from vehicle injury. (Tracy Hester, MRH.)

This group is gathered in a wooded area for an outdoor picnic around 1900. Such picnics were a pleasant way to pass a holiday or Sunday, provided the weather held. Off to the left, the few men in this group have chosen to sit by themselves. (Asher Collection, MRH.)

This island in Crystal Lake is still there. The bridge, however, is long gone. Crystal Lake today remains a quiet recreation spot for anglers in the spring, swimmers in the summer, and ice-skaters in the winter. In the late 19th century, Marquet's slaughterhouse dumped its effluent into the north end of the lake. Today, elegant homes line the portion of the shore that is not a public park. (RHS.)

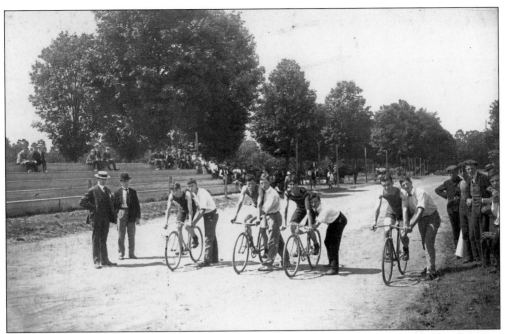

Bike racers with their handlers are on their marks waiting for the start of the race while observers are filling the bleacher seats at Springbrook Park around 1910, which would become the site of the Dutchess County Fair later in the decade. Note the absence of water bottles, sponsors, and special gear that are standard today. (Photograph by F. DuFlan; MRH.)

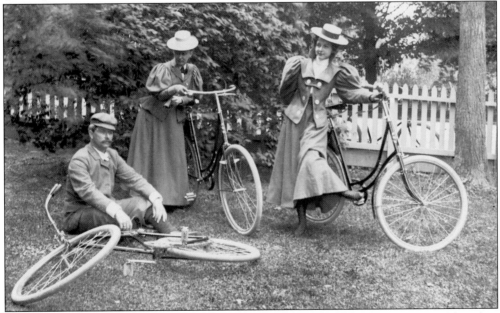

Bicycles were as much a source of leisure as they were a means of transportation, although it was challenging for women to ride without catching their dresses in the chains or spokes. The relative flatness of the village, the gentle surrounding slopes, and the attractive views made biking a great pleasure. And occasionally, a great estate might open its trails to the families of employees. (RHS.)

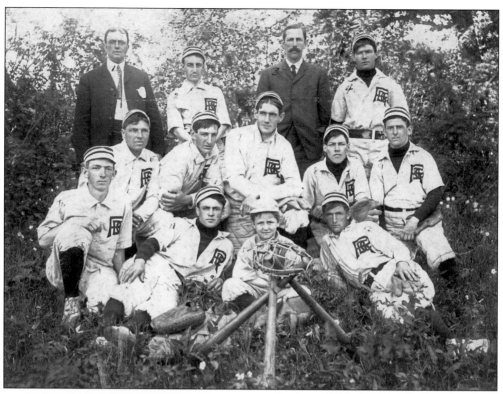

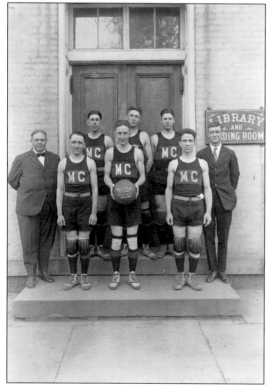

In this c. 1915 photograph, the Rhinebeck Baseball Club, all in their 20s, pose in uniforms with an attractive logo around batboy Bruce Brown. They played other teams from around Dutchess County. From left to right are (first row) Harold Van Auken, Ernest Fraleigh, Bruce Brown, and Jack Kolbinski; (second row) Charles Shaffer, Charles Williams, Fred Baldwin, Ray Ostrom, and William Moselein; (third row) Jacob Sleight, unidentified, William Tremper, and Landon Ostrom. (MRH.)

The Men's Club is in front of the Starr Building on April 10, 1921, having concluded a very successful 21-4 season. At left is the coach, Major Prince, and at right the manager, Isaac Van Keuren. Two of the players, at rear left and right respectively, are Stanton Tremper and Robert Gay. (Photograph by Ed Tibbals; MRH.)

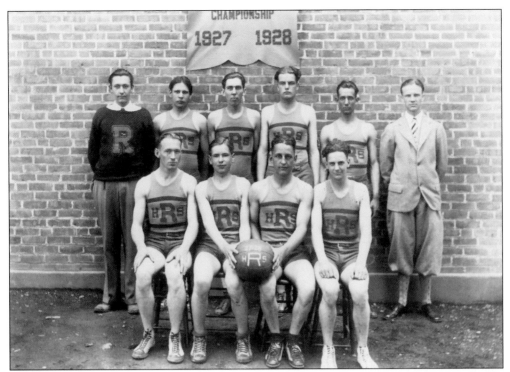

Rhinebeck was developing a strong reputation as a serious competitor in several sports in the late 1920s, especially in basketball. This particular team is the 1927–1928 championship team. The coach, Sunny Hildreth, is recognizable at right in knickers. Years later, the school board would name the gymnasium in his honor. The players are unidentified. (MRH.)

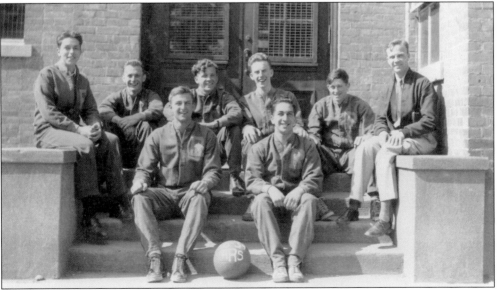

The 1938–1939 Rhinebeck High School basketball team poses with coach Sunny Hildreth at right. The coach brought out the best in his players, in attitude and in playing skills. The players are, from left to right, (first row) Jack King and Angelo Fichera; (second row) John Haskins, Tony Greco, Gordon Lattin, Jim Buckley, and James Whittaker. (MRH.)

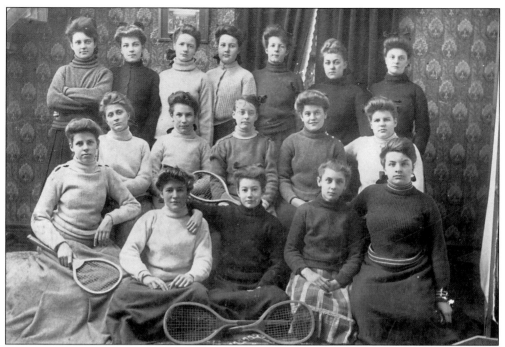

The Rhinebeck Tennis Club poses with their rackets around 1903. They have uniform hairstyles and heavy sweaters. From left to right are (first row) Clara Tremper, Mary Tator, Frances Cuckelmann, Lottie Hermans, and Verna Cornelius; (second row) Lulu Milroy, Florence Ritter, Hilah Paulmier, Elsie Cramer, and Lillian Tator; (third row) Mabel Welch, Julia Van Keuren, Irene Staley, Anna Milroy, Jessie Snyder, Helen Tator, and Birdie Carhart. (Photograph by Theo deLaporte; MRH.)

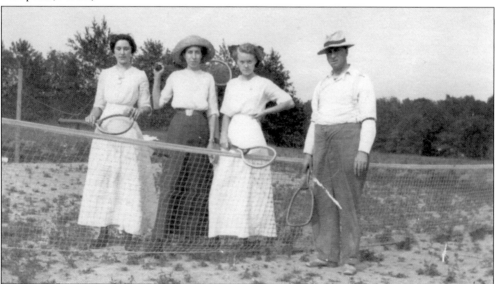

In August 1922, this tennis foursome is determined to play despite the challenging conditions underfoot. A player who could learn to respond quickly to the unpredictable directions a ball might bounce after striking a pebble or one of these patches of weed was one step up if he lasted long enough to compete against those who had learned on a perfectly manicured clay court. (MRH.)

These two dogs get the attention of Frederick Mohrmann. His farm was located east of the junction of Violet Hill Road and Route 9G. Fire destroyed the home's second floor; new owner Myron Furst kept it as a one-story structure. The property is now the Buttonwood horse farm. (MRH.)

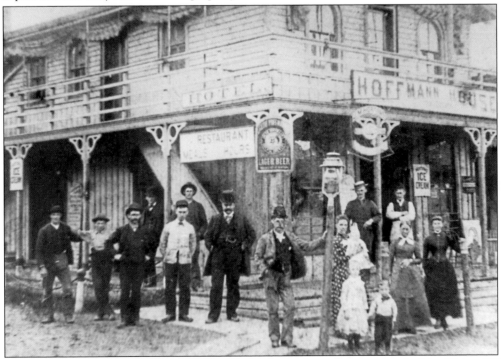

In this c. 1890 photograph, the Hoffman House Hotel adjoined the east end of the Rhinecliff ferry slip. Each hotel and tavern (of which there were many) had its own clientele and unique atmosphere. Where the Albany Post Road brought clients to Rhinebeck's hostelries, the train and ferry brought them to Rhinecliff. The proliferation of signs suggests that competition was stiff among hotel owners. (MRH.)

The Hudson River was often crowded with boats around 1915. Many boats took groups of tourists onto the river for a brief outing. The helmsman's tie floating in the wind and coats of the passengers indicate a windy day. The location appears to be across from Rhinecliff, just outside the entrance to the Rondout Creek. (American Legion, MRH.)

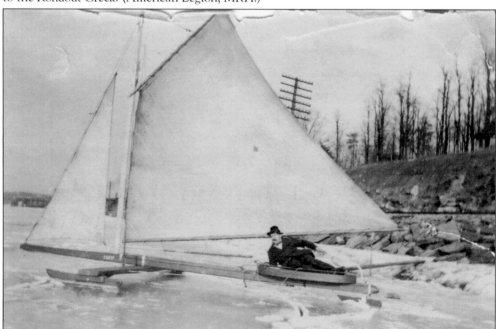

Pictured here around 1910, the iceboat *Imp* is just below Rhinecliff, the dock barely visible in the distance. In 1869, a larger iceboat, the *Icicle*, was fast enough to race the New York Central. Ice boaters can still be seen today when the Hudson River is solidly frozen, although ice cutters maintaining a clear channel along the western shore have made the sport more challenging. (Kay Verrilli, MRH.)

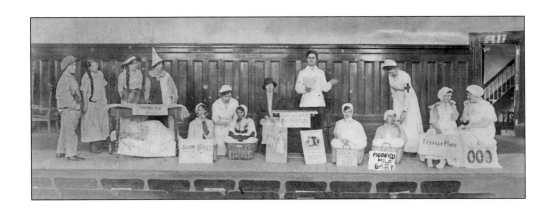

The Rhinebeck Town Hall served as a popular venue for theatrical performances in the late 19th and early 20th centuries. The scene above appears to be a spoof on child-rearing practices of the time. The baby lying beneath the table at left is the "Incubator Baby," followed by, from left to right, the "Slum Baby," the "Eskays Baby," the "Modified Milk Baby," and the "Perfect Baby." The woman at center is standing behind a sign that reads "Baby Welfare Exhibit." The scene below seems quite raucous, with half a dozen actors in dark clothing surrounding a cowboy. The two photographs are part of a set of four that sold for 50¢. (Both, MRH.)

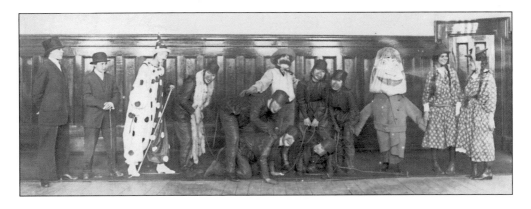

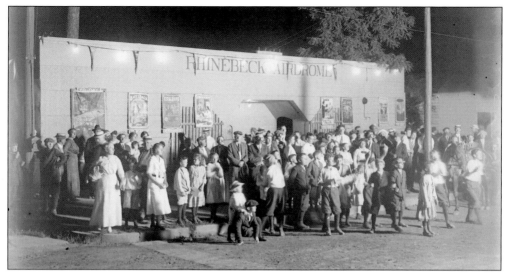

In May 1913, at the corner of Oak and West Market Streets, James Cozine opened the Rhinebeck Airdrome. He would rename it the Rhinebeck Aerodome in 1917. This was an open-air theater, popular with all ages, especially in warmer weather. Advertisements noted that "if stormy Saturday picture will be shown Monday evening." (Brewster Collection, RHS.)

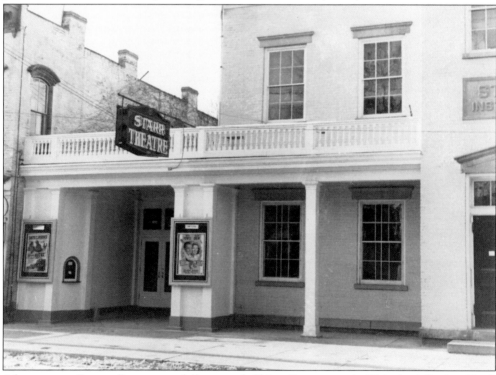

After attorney Benson Frost successfully persuaded his colleagues on the Rhinebeck Savings Bank board that a movie theater addition at the Starr Building would be a wise investment, it opened Christmas Day 1940. The Starr Institute dates to 1860, when William Starr Miller's widow decided that a public library would be an appropriate memorial, making it one of the oldest libraries in the state. (Photograph by Frank Asher; MRH.)

These boys at summer camp are patiently making a C and R. Shown here around 1927, Camp Rhinebeck was off the south side of Slate Quarry Road, just east of Route 9G, and run by Samuel McCord. There were numerous camps on the fringes of Rhinebeck, including Camp Ramapo, now a permanent site; Camp Rising Sun, which attracted an international clientele; and Camp Boiberik, now the site of Omega. (MRH.)

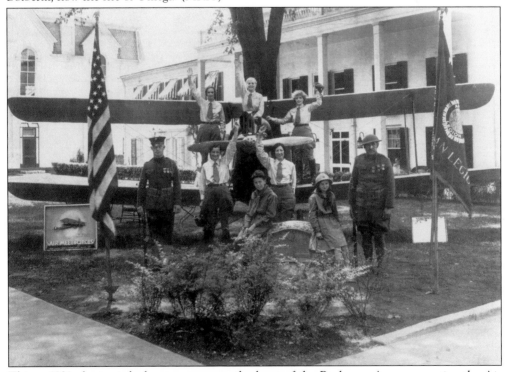

This c. 1931 photograph shows a group on the lawn of the Beekman Arms promoting the Air Meet Circus at Cozine Field sponsored by the American Legion. The two scouts sitting on the rock are John Tieder (left) and Marjorie Armstrong. Standing on the ground behind them are, from left to right, Harold Still, Betty Crockwell, Ruth Wilbur, and Roy Traver. On the wings are, from left to right, Beatrice Staley, Marjorie Van Etten, and Annette Benjamine. (MRH.)

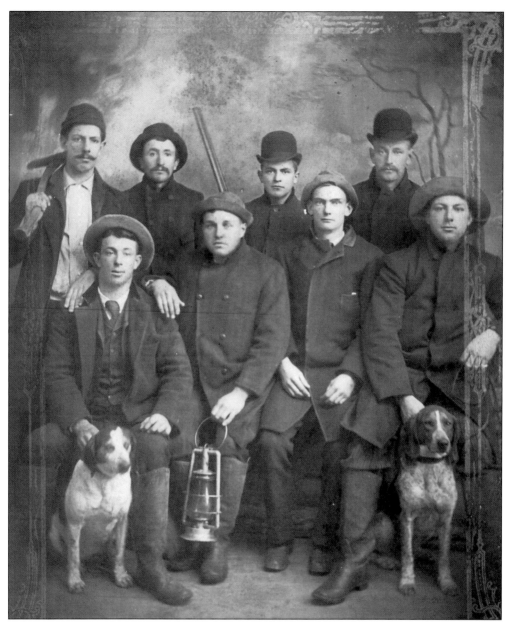

Shown here around 1915, members of the Rhinebeck Coon Hunters Club are ready for an outing. Henry Schaad is second from the right in front. The German short-haired pointer on the right and his mixed-breed cousin were particularly important members. The lantern, carried by the club member in front, is a reminder that the sport took place at night. One advantage, touted by some of its devotees, is that the sport does not interfere with a day job. Raccoon hunting was both a sport and an income source at the time of this photograph. Initially worn by American men in the 19th century as an emblem of their fur-trapping expertise on the frontier, coats sewn from the skins of raccoons became the rage with male college students in the 1920s. As a result, hunting clubs such as this one cashed in on the craze, while at the same time members enjoyed the fellowship of the hunt. (The Schaad family.)

The American Legion created Legion Park after a gift from the Huntington family. This February 1943 photograph from the lower part of the Landsman's Kill shows the dammed end of Crystal Lake upstream. There are still numerous scenes similar to this one along the back reaches of the streams coursing through Rhinebeck. (Photograph by Frank Asher, MRH.)

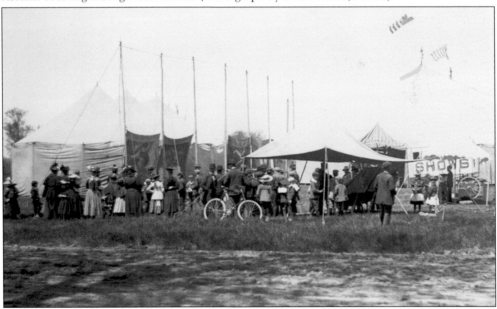

Flags flying from the tops of the tallest tents announced to all the arrival of the circus at the east end of the village around 1905. Barkers and colorfully painted canvas posters lured the public into the various forms of entertainment that the circus offered. The success of such events at Rhinebeck was a factor in the decision to move the county fair here in 1918. (RHS.)

In 1939, to illustrate Rhinebeck's history, Olin Dows painted 20 panels in the lobby of the new Rhinebeck Post Office. This photograph shows two of the panels. Dows painted similar murals in the Hyde Park, Poughkeepsie, and Wappingers Post Offices, while heading the Treasury Relief Art Project, which commissioned artists to do works for public buildings throughout the country. (Section of Fine Arts, Public Buildings Administration, Bard College Archives.)

Secluded upstream from where the Landsman's Kill crosses under South Mill Road, this gatehouse, as seen here in 1918, was made available to Thomas Wolfe on his frequent visits in 1925 by the family of Harvard classmate Olin Dows. The Dows family and the Hudson River made a deep impression on Wolfe that eventually found expression 10 years later in his novel *Of Time and the River*. (Photograph by Harry Coutant; MRH.)

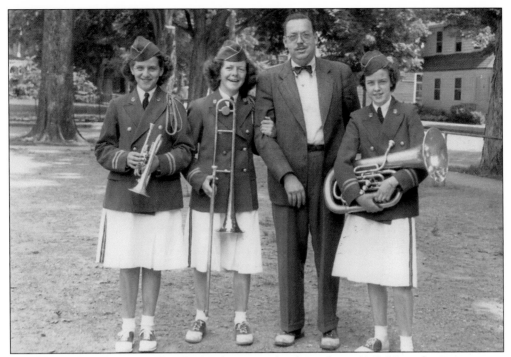

The Rhinebeck High School band was a favorite at local parades in 1943. Here, they are stepping away from their routine to have a little fun. Three of the brass band members from left to right are Dorie Ann Stone, Lorraine Briggs, and Irene Stone. These cousins have cornered the band director Bernard Windt for a photograph. (Photograph by Frank Asher; MRH.)

To celebrate the 1976 bicentennial, town historian Dewitt Gurnell (at right) persuaded the Coast Guard to donate this bell from the decommissioned Rondout Lighthouse. The bell arrived first at the Rhinebeck Savings Bank plaza, pictured here. It is now at the Reformed Church among the graves of many Revolutionary War veterans, where it also serves as a memorial to "Uncle Dewitt," as he was known to local children. (MRH.)

DISCOVER THOUSANDS OF LOCAL HISTORY BOOKS
FEATURING MILLIONS OF VINTAGE IMAGES

Arcadia Publishing, the leading local history publisher in the United States, is committed to making history accessible and meaningful through publishing books that celebrate and preserve the heritage of America's people and places.

Find more books like this at
www.arcadiapublishing.com

Search for your hometown history, your old stomping grounds, and even your favorite sports team.

Consistent with our mission to preserve history on a local level, this book was printed in South Carolina on American-made paper and manufactured entirely in the United States. Products carrying the accredited Forest Stewardship Council (FSC) label are printed on 100 percent FSC-certified paper.

MADE IN THE USA